Photographing Families

Designing Custom Portraits

Elizabeth Homan, M.Photog.Cr., API, CPP
Trey Homan, Cr.Photog., CPP

AMHERST MEDIA, INC. BUFFALO, NY

Published by:
Amherst Media, Inc., P.O. Box 586, Buffalo, N.Y. 14226
www.AmherstMedia.com

Publisher: Craig Alesse
Senior Editor/Production Manager: Michelle Perkins
Editors: Barbara A. Lynch-Johnt, Beth Alesse
Acquisitions Editor: Harvey Goldstein
Associate Publisher: Kate Neaverth
Editorial Assistance from: Carey A. Miller, Sally Jarzab, John S. Loder
Business Manager: Adam Richards
Warehouse and Fulfillment Manager: Roger Singo

ISBN-13: 978-1-60895-929-7
Library of Congress Control Number: 2015939886
Printed in The United States of America.
10 9 8 7 6 5 4 3 2 1

www.facebook.com/AmherstMediaInc
www.youtube.com/c/AmherstMedia
www.twitter.com/AmherstMedia

Contents

About the Authors 5

1. Hill Country Baby 6
Selecting the Time of Day, Goal of the Session, Planting the Seeds for the Sale, Know the Smile-Making Poses

2. A Sunken Garden 8
Work with Clients on Color Scheme, Utilizing Levels, Groups and Breakdowns, Lighting the Subjects, Entertaining the Children

3. Dune Sunrise 10
Be Mindful of the Wind, Look for Vantage Points, Photographing Teenagers

4. You Lift Me Up 12
Photographs Tell a Story, Give Them Variety, Key to Interactive Portraiture, Do Whatever It Takes for Expression, Lighting

5. Fall on the Guadalupe 14
Autumn Colors, Giving the Effect of Fall, Train Your Clients, Working with Older Kids

6. Seaside Generations 16
Seagulls Add Interest, The Importance of an Assistant, Posing on the Beach

7. Generations in Springtime 18
Planning the Session, Photograph All Possible Combinations, Look for the Perfect Shade

8. Waterside, Wind and Waves 20
Light from the Rising Sun, A Favorite Pose, Fooling the Seagulls

9. Urban Family 22
Creating a Contemporary Look, Getting Their Attention

10. The Big Apple 24
Location, Repeat Clients Are the Best Clients, Destination Portraits, Getting Everyone's Attention

11. Back to Nature 26
A Moment in Time, Capturing the Expression

12. Flowers and Fun 28
Bluebonnets, Seize the Moment, End of Day Sessions with Small Children

13. A Special Time at Home 30
Photographing a Family with a Special Needs Child, Make the Best of Adverse Conditions, Have the Portrait Tell the Story

14. Summer in the Park 32
Finding a Great Location, Creating Memories, Variety in Posing and Composition, Working with Children

15. Waterfall Backdrop 34
Cultivate Premiere Clients, Posing Larger People, Popular Settings Can Change, Being Gross Evokes Expressions

16. Holding Hands in the Park 36
Know to What the Child Will Respond, Vary the Posing and Locations, A Natural Foundation

17. Majestic Mission Door 38
Mission San Jose, Planning Consultation, Know Your Location, Composition, Exposure, Lighting, and Settings

18. Where the Heart Is 40
Communication, Be Prepared for Last Minute Change of Venues, Secondary Images

19. Formal Family Gardens 42
My Client, Her Patient, Trey and His Bag of Tricks, Photographing for an Album

20. A Bluebonnet Afternoon 44
Generational Portraits, A Short Window of Time, Bring the Necessary Props, Positioning

21. NYC Bright Lights, Big City 46
Explore New Venues, Good Weather, an Agreeable Teenager, and Numerous Locations

22. Resting in Our Arms 48
Relationship Portrait, Getting the Baby to Sleep, Tricks for Little Children, Lighting the Subjects

23. Family Traditions 50
Portraits with Meaning, Lighting and Exposure, Photograph for Variety

24. Museum Arches 52
Creating Memories from Special Moments, Designing the Session, Composition, Lighting and Camera Information

25. Home Sweet Home 54
Portraits Made in the Home Have Special Meaning, A Star Was Born, Think Outside the Box

26. By the River Bank 56
The Environment as a Posing Tool, Know the Contemporary Lingo

27. Backyard Party **58**
Sometimes You Cannot Reschedule, Hawaiian Flair, Clothing Changes

28. Family in Red **60**
Using a Natural Background, Secondary Images, Holiday Portrait Special Sessions

29. Historic Architecture **62**
Architectural Surfaces, Photographing an Active Child

30. Cabin Fever. . **64**
Clothing Guidelines, Creating Levels, Children Should Be Rested and Fed

31. Skipping Rocks by the River **66**
Early Morning Light, Let Kids Be Kids, Fun Poses

32. Lavender by the Pond **68**
Multi-Generational Portrait, Discards Can Wind Up in an Album

33. Bringing Baby Home **70**
Finding the Perfect Location, Give Them a Variety of Secondary Images, Allow More Time for Newborns

34. The River Runs **72**
The Shy Child, Get to Know Your Subject, Family Day Events

35. Family by the Fireplace **74**
Photograph Your Client in Their Favorite Place, Find Out the Magic Word, Know the Needs of a Long Time Client

36. Family Time . **76**
Repeat Clients Are the Best Clients, Early Morning Light, Obtaining Permission or Permits

37. Hawaii: Sunset in Paradise **78**
Photographing After Sunset, Painted Portrait

38. Cypress Leaves and Twisted Bark . . . **80**
A Different Perspective, Entertaining the Baby

39. Big Red Barn **82**
Popular Location, Find a Motif That Fits Your Clients' Personality, Perspective, Be Prepared for All Situations

40. On the Porch **84**
Multi-Purpose Building, Utilizing the Property, Leave Them Wanting More

41. Family at the Mission. **86**
Color Harmony, Time Constraints, Indirect Lighting, Architecture and Posing, Creating Dimension

42. Trickling Stream **88**
Perfect Size Group, Early Morning Session, Getting the Parents to Listen

43. Country Chic **90**
Long-Time Client in an Old Town, White and Turquoise, It Is Fun to Photograph Fun People

44. Sands of Time. **92**
A Referral from Another Photographer, Getting to Know the Subject

45. Classic Black & White **94**
Relationship Portraits, Photograph in Color, Convert to Black & White, Different Background for Different Looks

46. Family Tree . **96**
Going the Extra Mile with a New Client, Coordinating Colors, Creating Levels and Depth

47. Nine Kids and Counting **98**
Reconnecting with an Old Client, Cooperation

48. Shades of Pink **100**
Pastel Colors and Casual Attire, Challenging Age Groups, Posing in a Perfect World

49. The Bond of Family **102**
Black & White Portraits, Creating Timeless Portraits

50. Dad Wore Red **104**
Photographing in a Park, Finding a Less Crowded Place to Photograph, Non-Seasonal Seasonal Portraits

51. Sand Between Our Toes **106**
Sunrise on the Beach, Overcoming Energetic Children, Creating a Wall Collection

52. Gathered All Together. **108**
Large Groups, Limited Space, Pre-Portrait Consultation

53. Family Made of Love **110**
Creating a Flattering Portrait, Mastering the Individual Poses

54. The Family Farm. **112**
Posing Amongst the Cow Patties, Early Morning Sunlight, Complementary Clothing

55. Expectant Family **114**
Creating Drama, Earning Mom's Trust, Black & White versus Color

56. Footsteps in the Sand **116**
Destination Portraits, Learn to Work Quickly, Vacationing Families Are Relaxed, Be Alert for Unexpected Treasures

57. Field of Blue **118**
Unique Designs, Create a Market for Your Top Product

58. Texas Family Ranch **120**
Proper Use of an Old Shed with Character, Include Everybody in the Secondary Images, Late Day Sun

59. Vibrant Texans **122**
Sometimes Mom Does What She Wants, Creating a Simple Portrait

60. A Family's Best Friend. **124**
Pets Are People Too, Overcoming the Non-Smiler, Making Dad Smile

Index . **126**

About the Authors

Elizabeth Homan, M.Photog.Cr., API, CPP
Trey Homan, Cr.Photog., CPP

Elizabeth and Trey Homan own and operate Artistic Images Portrait Studio in San Antonio, Texas, where they have enjoyed a very successful business for the past twenty-three years. The studio is located on two and a half wooded acres where they have created a beautiful portrait garden. Elizabeth is known for her artistic portraiture of families, children and seniors, and her dynamic images of brides.

Elizabeth has won many awards for her wedding photographs, portraiture and portrait albums. She also has fourteen Fuji Masterpiece awards, five Kodak Gallery awards and many Professional Photographers of America Loan Collection images. She was selected as a PPA ELITE member in 2014 and 2015, one of only twenty-six members selected out of 27,000 for photographic excellence!

Trey manages the studio, computer systems, album design and designs all of the marketing pieces. Trey is also known as the *baby whisperer* and has a fantastic rapport with children of all ages.

Trey and Elizabeth have three young boys, one with special needs, who keep them busy. When they are not at home with their sons or working at the studio, they travel around the country giving seminars to other photographers. Elizabeth and Trey love what they do and hope to always be able to encourage others to get the most out of this wonderful profession!

Hill Country Baby

Selecting the Time of Day

This family came to San Antonio for a holiday, staying at one of the local beautiful resorts, and was referred to me by another client. We had arranged the session in advance, and I met them at sunrise at the resort. We chose sunrise because I prefer to work early in the morning or late in the day. And with small children, early in the morning is better than later in the afternoon. It was also better to work early in the morning because this session was in early July, and it gets very hot in San Antonio by mid to late morning.

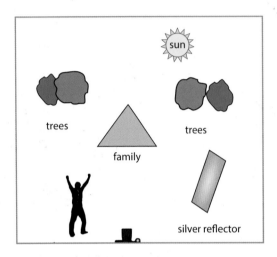

Goal of the Session

This is the family's first child, and their lives revolved around this little five-month-old boy. The goal of the portrait session was to capture this new family in their first family portrait, and show the environment of the hills and plains of San Antonio so

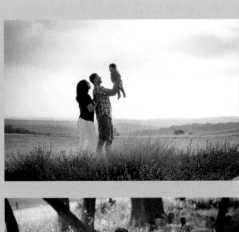

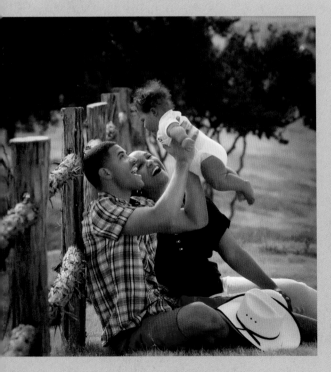

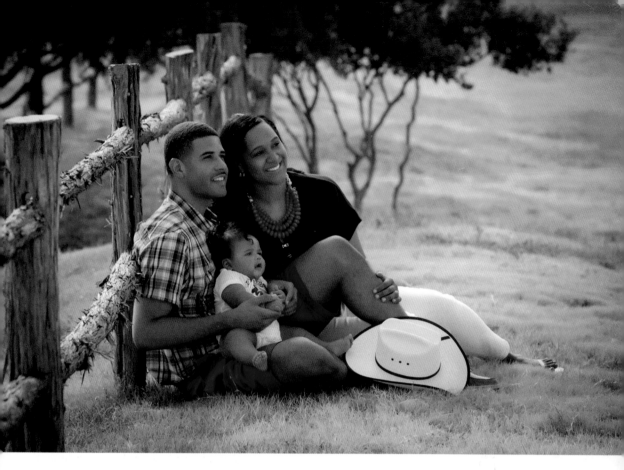

that they can remember where this image was created.

Planting the Seeds for the Sale

With all of my sessions, my principal objective is for my clients to purchase not only a wall portrait, but an album as well. This is one of the reasons that I try to give my clients a variety of poses and expressions, offering them the opportunity to enjoy what I have created for years to come.

Know the Smile-Making Poses

In the primary image *(above)*, I had the family looking at my assistant, and my assistant is making the baby laugh. In some of the other photographs, I had the baby turned around with either Mom or Dad lifting him up, which is always a great smile-maker for everybody. We continued to mix it up, so they were not just staring at my assistant keeping the baby entertained the entire time.

Exposure, Lighting, and Settings

The primary image (and two of the other images) was photographed with a 70–200mm lens set at 200mm on my Canon 5D Mark III set at f/5.6, $\frac{1}{125}$ second, and ISO 400, using only available light and a reflector. I used a 28–70mm lens for one photograph to get a little broader view of the background.

2 | A Sunken Garden

Work with Clients on Color Scheme

Grandma and Grandpa were the center focus for this fiftieth-anniversary celebration portrait session, but we also wanted to feature their children and grandchildren. The grandparents weighed heavily on the color scheme that they wanted. They chose purples, blues, greens, and the one singular magenta sweater.

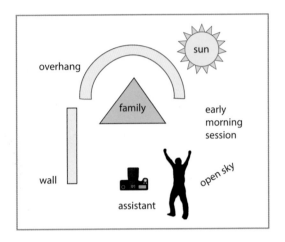

Utilizing Levels

These images were photographed on a beautiful January day at the Sunken Gardens in San Antonio. I like using this area because it has a lot of different levels where I can place my subjects. I always want to be sure that I never have any heads on a straight line, either vertical or horizontal. I can easily mix up the angles at this location; I have people standing, sitting, and perched on the ledge. In the primary image, I worked with an inverted triangle, with the couple on the bottom at the apex.

Groups and Breakdowns

I typically photograph a variety of poses with the entire group, as well as breakdowns with the smaller family units. I will pull the grandparents forward *(top)* so that they are more center-focused with the family in the background; this adds interest and variety to the selection of images.

Lighting the Subjects

I was working with one hundred percent available natural light; the family was underneath a giant overhang and the sun was about ten feet to the right of the overhang.

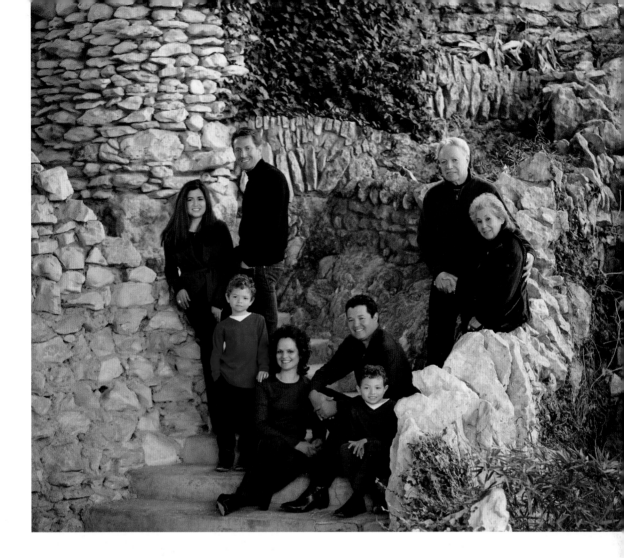

The majority of light was coming from behind and camera right. This is a wonderful location because there is almost always shade and nice directional light, so I do not have to add any flash or reflectors. This series was photographed at approximately 8:00 AM, which was probably a little later than when I would have preferred to start.

Entertaining the Children

When Trey is working with children in the five and younger range, he uses a bag full of toys and puppets to entertain them. He hides a puppet in a place where it is partly visible and peeking out, saying that he lost it, and asks the children if they know where it is. We will then play a game trying to find the puppet, getting them involved, and having fun. He drags out this game until not only are the kids laughing, but the parents are laughing as well.

Exposure and Settings

I created this image with my 70–200mm lens set at 85mm. My exposure was f/8 at $\frac{1}{125}$ second and ISO 640.

3 | Dune Sunrise

Be Mindful of the Wind

This image *(below)* was created on a beautiful, but windy, sunrise at North Padre Island off Corpus Christi, Texas. Because Mom and her daughter's hair kept sweeping into their faces, I turned their backs to the camera and had them look into the wind, blowing their hair behind them. They loved this pose so much that they purchased it for their primary wall portrait.

Look for Vantage Points

We had a great sky in the background and a number of clouds. The beach was strewn with a lot of seaweed, about three feet deep and ten feet wide, extending all the way down the beach, and creating an obstacle. I found this little place above the sea wall with a promenade just beyond this point, so I was able to photograph the family without showing the beach.

The other images were photographed before the sun rose, using an off-camera flash. There was a necessity for the flash

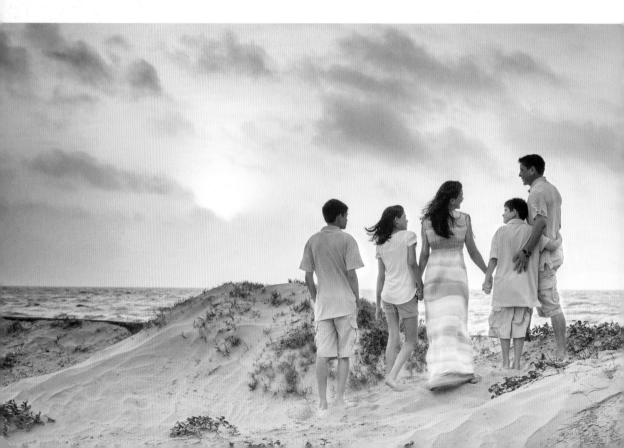

because there was not a lot of directional light from the sun yet. The clouds came and went, so I had Trey on camera right holding the off-camera flash, which had not been needed for the main image of the family facing the water. The wind was whipping around, and we had to face the family in one direction so that the mother and daughter's hair would not fly in front of their faces.

Photographing Teenagers

The action photo of the family walking towards me *(middle)* was made at sunrise, and my personal observation is that teenagers and sunrise are not always the best combination. I was catching a little attitude with the two older kids because they were not happy about being on the beach that early in the morning. Teenagers tend to like to sleep late, and getting them up before sunrise can be problematic. The session ended with the twelve-year-old girl throwing sand in her fourteen-year-old brother's face. At that point, we were finished.

Exposure, Lighting, and Settings

This image was created with one hundred percent pure natural light coming from the rising sun. I used my 70–200mm lens set at 180mm on my Canon 5D Mark III. My exposure was f/4.5 at $\frac{1}{125}$ second and ISO 1000.

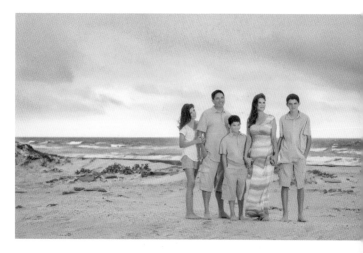

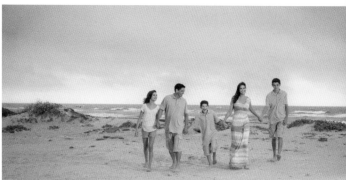

You Lift Me Up

Photographs Tell a Story

I had photographed Mom and Dad when they had only six children. Not long after that session, Dad was diagnosed with cancer. He lived long enough to see his youngest son born. Mom wanted an updated portrait showing her new life with her seven children; she wanted something interactive and playful.

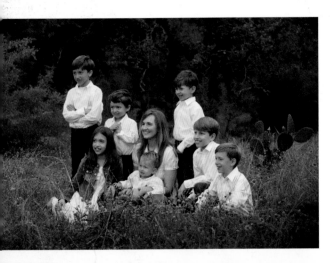

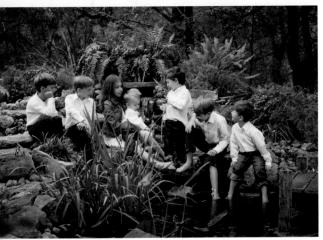

Give Them Variety

I created a series of images of the entire family, as well as just the kids without Mom. Because she was more interested in the interactive, this was what we focused on. I asked Mom to lift the baby in the air and have the kids look at him and smile. It was important to work quickly because I did not want the kids to lose interest. I made the exposure as she lifted the baby up while all of the kids were paying attention.

Key to Interactive Portraiture

One of the keys to interactive portraiture is not to have the kids too close to each other. I wanted them spread out into three distinct groupings, and I wanted Mom and the baby to be the center-focal point. This would divide the portrait into three pieces, called a triptych, creating a dynamic presentation of three definitive gallery-wraps to be displayed next to each other on the wall.

Do Whatever It Takes for Expression

It is very difficult to get seven young children to look at the camera or my assistant at the same time. In the photo of the kids by the pond, we gave the youngest one a leaf and all of them looked at it—or at least faked interest in it—keeping the impression of an interactive portrait. Trey used a ball attached to an elastic string for some of the images. He threw the ball towards

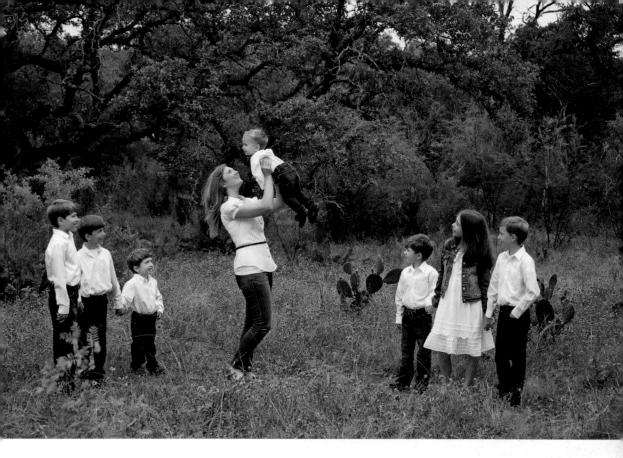

the youngest, then ran away as the ball followed him, causing all of the children to laugh, including the baby. Trey will do whatever it takes to get the expression; he describes himself as a middle-aged man who never grew up.

Lighting

We started photographing around 8:00AM on a cloudy, overcast day. The sun was behind the clouds at camera right, and I used an off-camera flash at camera left. Because there was not much sun, I needed a flash to give directional light.

Exposure and Settings

This image (*above*) was made with my Canon 5D Mark III with my 70–200mm lens set at 80mm. My exposure was f/5.6 at $1/200$ second.

5 | **Fall on the Guadalupe**

Autumn Colors

This is a pretty area at the Guadalupe River, which is north of San Antonio. Fall in San Antonio is very short. Consequently, we have a brief period to photograph or we miss out on the beautiful tones in the background. The time may vary when we

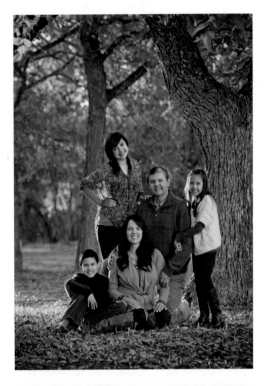

will get these wonderful array of tones, the earliest being the end of September, and the latest being the end of October, depending on how cold it has been. As soon as the leaves turn orange, they are going to die quickly, giving us a small window in which to plan sessions.

Giving the Effect of Fall

The early morning light coming through the trees, backlighting the area, made it look more like fall. This particular image *(facing page)* has been painted, adding to the feel of autumn; I did not enhance the color, I just used the software Painter for the overall image. Their clothing also helped to bring out the fall colors of the background. I have this portrait displayed in my studio as an example of how to put clothing together. There is a touch of pattern in the blouse of the girl sitting on the

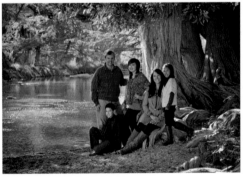

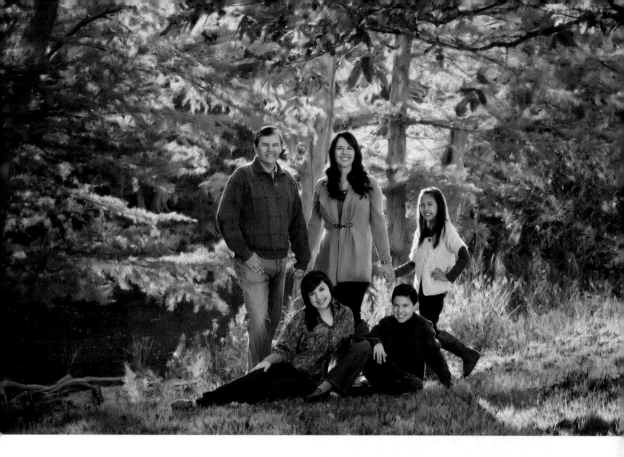

ground and Dad has a little pattern in his sweater, but they are soft and muted, and do not overpower or dominate the image.

Train Your Clients

This family comes to me every year for a portrait session, and we always photograph them in a different location. After so many years, I have coached them on how to put their clothes together and how to pose; they are almost professionals.

Working with Older Kids

This was a very easy family to work with. Because the kids are a little older, Trey used a lot of self-deprecating humor, doing his famous maternity pose where he appears to be pregnant, pushing out his belly as far as it will go, holding it as a mother-to-be might hold her unborn baby. He teased them about boyfriends and girlfriends, and Mom and Dad's smelly feet or stinky armpits. Body odors are funny to kids this age, especially boys. As Trey joked with the family, I was giving him directions as to where he needed to stand. He had everyone's attention and led their eyes to look in the desired direction.

Exposure and Settings

This photograph was made with my Canon 5D Mark III with my 70–200mm lens set at 80mm. My exposure was f/8 at $1/125$ second and ISO 500.

Seagulls Add Interest

Seagulls are always nearby when we photograph on the beach. If they think we have food and we pretend to feed them, they will come close to us. They remain until they realize that we are not really feeding them, and they will leave for a short time until we start the charade all over again. They add interest and background to the photograph, and then we hope they fly away before they mess on somebody's head.

The Importance of an Assistant

An assistant needs to be visible and loud because it can be noisy on the beach with the wind, seagulls, and the waves crashing on the shore. Trey hams it up as he tells his jokes, stretching out a joke as long as ten minutes. His central function during the photo session is to get the family to tune in on him as I capture the images. I direct Trey the entire time as he works with the family for a variety of expressions. I might

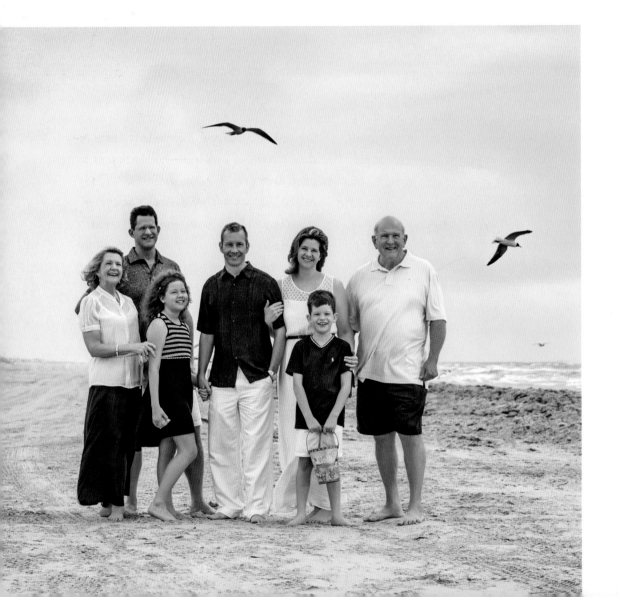

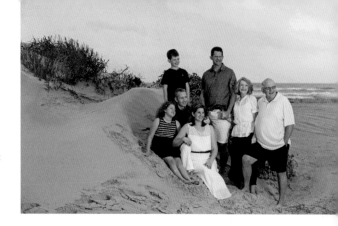

have him move a little more to the right or get closer to me, and the subjects' faces and eyes follow him. By doing this, he is able to direct their faces towards the light.

The day we photographed this family, we were surrounded by clouds with no directional light from the sun. We were working at sunrise with no sun, and Trey was standing on camera right holding an off-camera flash. It was essential that he held the light while he made the kids—of all ages—laugh.

Posing on the Beach

It was a windy morning, but I worked with the wind, not against it. The wind was blowing the hair behind them, rather than to the front of their faces. I usually wait until the end of the session to pose them sitting in the sand *(top right)*, especially if it is wet sand, as this will show on the clothing. If it is dry sand, it will easily brush off. Many of my poses on the beach are stand-

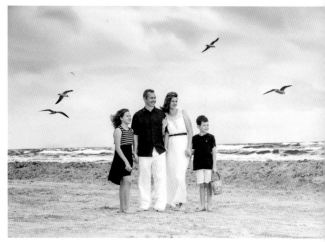

ing and walking, and I try to have them put their weight on one foot—the back foot is best—so they are not standing flat-footed.

In this image *(facing page)*, the grandparents are the anchors, with one on either side, and their children and grandchildren between them. They are the foundation for this family, for their daughter and her family, and for their son. This couple is who started their clan.

Exposure and Settings

I used my 70–200mm lens set at 150mm on my Canon 5D Mark III. My exposure was f/5.6 at $\frac{1}{125}$ second and ISO 400.

7 | Generations in Springtime

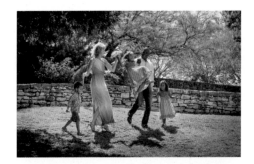

This was an extended family session with images taken of the two brothers and their parents, the grandparents with all of the grandchildren, as well as photographs of the individual families. Some of the photographs also include the wife's parents from the Philippines.

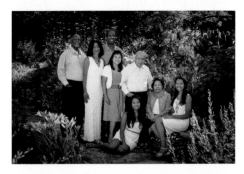

Planning the Session

The portrait session was at the San Antonio Botanical Gardens and was planned far in advance. The families traveled great distances for this special day. The wife's parents came from the Philippines, and others had come from California. They planned to visit and vacation together and have me photograph all of them while they were here. It was fortunate that I photographed them at this time because the grandmother from the Philippines took sick shortly after this vacation and passed away not too long after.

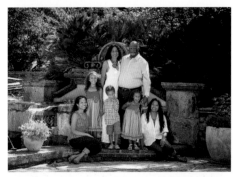

Photograph All Possible Combinations

I have been photographing the family with the older daughters since they were little girls. Mom likes bright colors, so she chose vivid greens and blues for one of the outfits, and then they changed into bright pink and white for a different series. I spent approximately two hours photographing throughout the grounds of the gardens and all of the different combinations and breakdowns starting with the entire group, just the kids, each mother and father with their children, the grandparents with their grandchildren, and the grandparents by themselves. It was

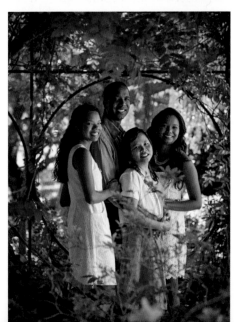

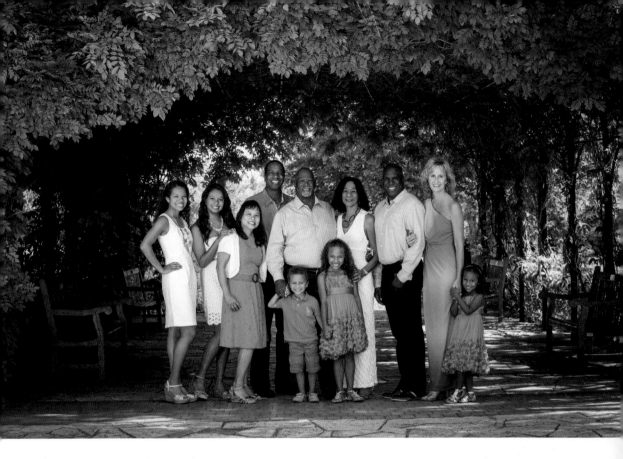

a beautiful day, and it was a benefit that the weather was fine and the large extended family so accommodating.

Look for the Perfect Shade

We started the day around 9:00AM when the grounds opened. I looked for open shade and an area where I could backlight the subjects because it got bright very quickly. In the primary image *(above)*, I placed the family at the front edge of the arbor overhang, which cuts off the overhead light and forces the light to come into their faces. Using the overhang was important because of how bright the day was. I used a 4x4-foot reflector on camera left to bounce light back into their eyes and their faces.

Exposure and Settings

The primary image was photographed with the 70–200mm lens on my Canon 5D Mark III set at 85mm. My exposure was f/8 at $\frac{1}{125}$ second and ISO 400.

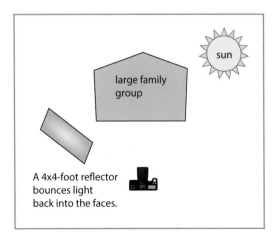

large family group

sun

A 4x4-foot reflector bounces light back into the faces.

8 | Waterside, Wind and Waves

Light from the Rising Sun

This early morning image was created before the sun rose over the horizon. The light from the rising sun can be seen coming up above the clouds over the water. It was photographed at sunrise with natural light and Trey was standing in the water, holding an off-camera flash ninety degrees at camera right.

The supporting image of Mom and Dad kissing at the edge of the shore *(top right)* was timed perfectly as the sun peeked above the clouds over the water. Trey was standing in the water, illuminating them, holding an off-camera flash. I love how her skirt billowed just a bit from the wind, and the seagulls appeared over-head, as if on cue. We were fortunate to have beautiful clouds that day and enough wind that worked with her outfit and her hair.

The sun was the main light in the pose where the family was standing by the water's edge facing me *(facing page)*; the sun was too bright and they could not look at it. My rule is that if I am going to use the sun as the main light, they have to be able to look toward it. It also has to provide a soft light, usually behind a cloud.

A Favorite Pose

I often photograph families from the back; I like to show them walking along the shore. I will photograph them from the front walking towards me as well, but I really like the walking away images. Some families prefer poses where the faces are clearly visible, but I always do at

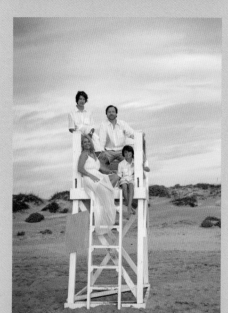

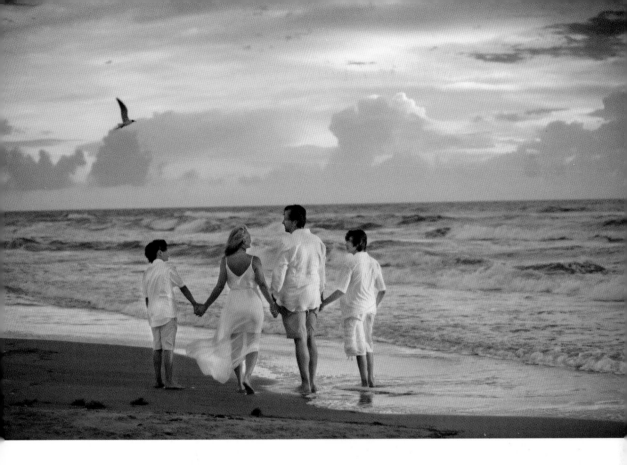

least one pose like this because even though they thought they did not want this pose, it becomes their favorite and their choice for their wall. It sometimes takes seeing it to make it happen.

Fooling the Seagulls

This session was photographed at a national seashore and it is illegal to feed seagulls at this location. As mentioned in an easier section, all we did was make a motion as if we were throwing food into the air and the seagulls come close to us. This is how I was able to draw the birds into the photograph.

Exposure, Lighting, and Settings

This photograph was made at South Padre Island using my Canon 5D Mark III with my 70–200mm lens set at 70mm. My exposure was f/3.2 at $^1/_{125}$ second and ISO 400.

Urban Family

Creating a Contemporary Look

I have been photographing this family for a long time. They requested a vertical pose for a specific location in their home, and to create a vertical photograph, I needed a vertical space. They wanted a contemporary look, so we rented a warehouse in downtown San Antonio. To complete the look, Mom came up with the black, gray, and red color scheme, which gave us a plan for the way the portrait should look and gave it a little attitude.

The pipe on a diagonal dissecting the family *(below)* breaks most photographic rules, with half on one side and half on the other, with the young boy right in the middle at the base of the pipe. It might break many rules on occasion, but this rule breaker certainly worked well in this photograph. They loved this image. I made sure that I placed the son and his wife and their two children on the top to balance the pose so that there was not too much weight on the bottom.

In the supporting image that was made in the parking garage *(top right)*, there was a light overhead and there was also light coming through the windows in the background to give them a little backlighting. I was standing outside the garage, photographing into the building, with the light from the front of the garage illuminating my subjects. I brought the chair for Dad to sit down because he was my anchor man, and I posed the rest of the family around him.

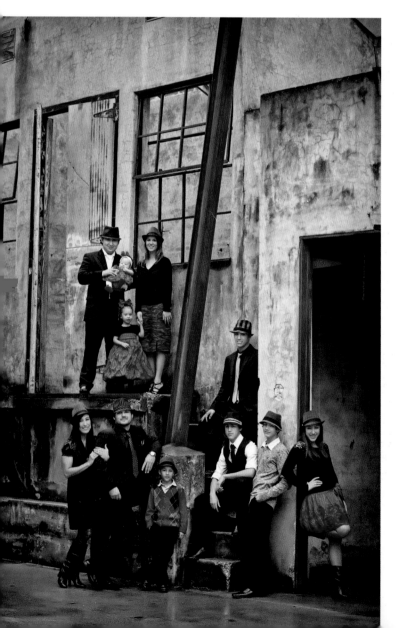

Getting Their Attention

Trey had focused his antics on the second youngest girl and the youngest boy, not worrying about the baby because a baby will do whatever she wants. He would run up to the little girl and act like he was going to kiss her hand, run back as if bashful, then run up and do it all again. Then he would run over and give the boy a high-five. He just continued to run back and forth, mixing it up, so they did not know what to expect. He is a master at maintaining and directing the subjects' attention.

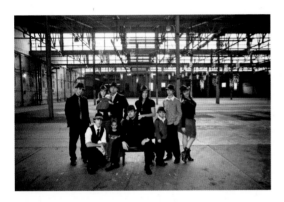

Exposure, Lighting, and Settings

This photograph was made outside of a warehouse early in the morning. The sun was behind the clouds to camera right as they stood under an overhang. I used an off-camera flash about forty-five degrees to camera right. My 70–200mm lens was set at 73mm. My exposure was f/6.3 at $\frac{1}{125}$ second and ISO 400.

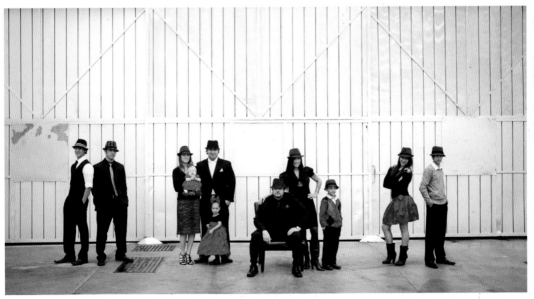

Location

This photograph was made in Central Park in New York City, very near the Plaza Hotel. The sun was peeking over the buildings behind the family on camera right.

Repeat Clients are the Best Clients

This San Antonio family is part of our core group of clients that come to us every year without fail; they are like our extended family. The grandparents stood in the middle on top of the rock; they have three sons, the two in tan sport jackets and the gentleman in the dark blazer on the right. I began photographing the family when the three sons were in high school. We had not photographed them in many years until the daughter-in-law sitting on the rock with the baby in her lap contacted me for a portrait. Once we began photographing her family, we regularly photographed the whole family.

Destination Portraits

They travel to New York City—The Big Apple—every Thanksgiving, and asked if I could join them there for a portrait session. We had a beautiful, but cold, day in the city. It was around thirty degrees when we began the session; Central Park was our second or third stop for portraits, at about 10:00AM. This was the pose they selected for their 50-inch canvas that is displayed in their home. When I schedule destination portraits, I require at least two families to make it worth my while.

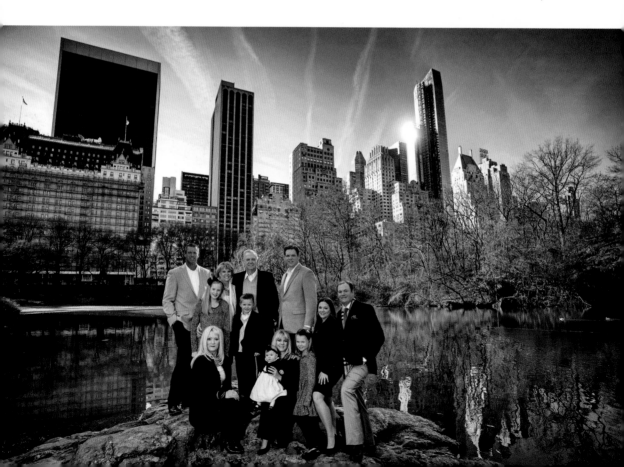

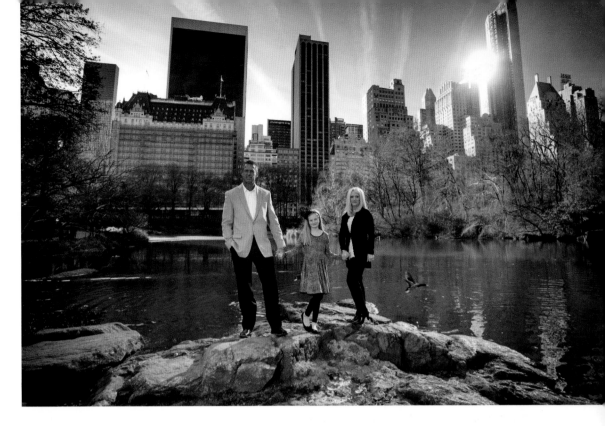

Getting Everyone's Attention

To get the attention of the children—and everyone else—Trey would bounce a soft ball off me encouraging them to look directly at me and smile. He did this as he was holding the flash on camera left.

Exposure and Settings

I used an off-camera flash about forty-five degrees to camera left. My 17–35mm lens was set at 17mm; my exposure was f/5.6 at $\frac{1}{200}$ second and ISO 125.

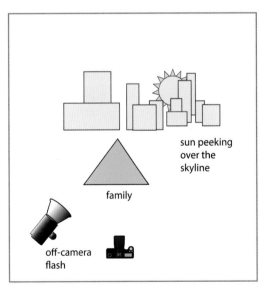

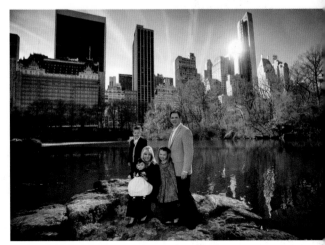

Back to Nature

A Moment in Time

My favorite photos from this session are the ones where the baby has such a natural expression, and I captured a moment in time, not just what they looked like. This is my goal when I photograph families. I want to capture who they are and this special moment in their lives, and not just the expressions on their faces. While capturing

their likeness is important, I believe that is secondary to the storytelling nature of what I am trying to create.

Capturing the Expression

This family was sitting under good cover from the trees with an open sky to their left, with a lake close by. Trey was standing right at the edge of the water, ninety degrees to camera left, right where the image stops, trying to get the baby's attention. Mom and Dad were looking at Trey as he worked to get the expressions from all of them.

Trey used a feather duster for this image as he stood off to the left and tickled the baby's nose, getting everyone to smile. In the primary image (*facing page*), the baby is pointing to the ducks in the water. Trey would love to take credit for the ducks coming close to shore and amusing the little

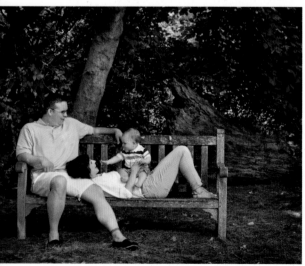

boy, but they were just there. This little boy was happy, excited, animated, and easy to work with. The parents loved the photos of their son smiling and being so happy; we can sell portraits like these all day long.

Exposure and Settings

The 70–200mm lens on my Canon 5D Mark III was set at 95mm. My exposure was f/5 at $\frac{1}{160}$ second and ISO 400, using only natural light.

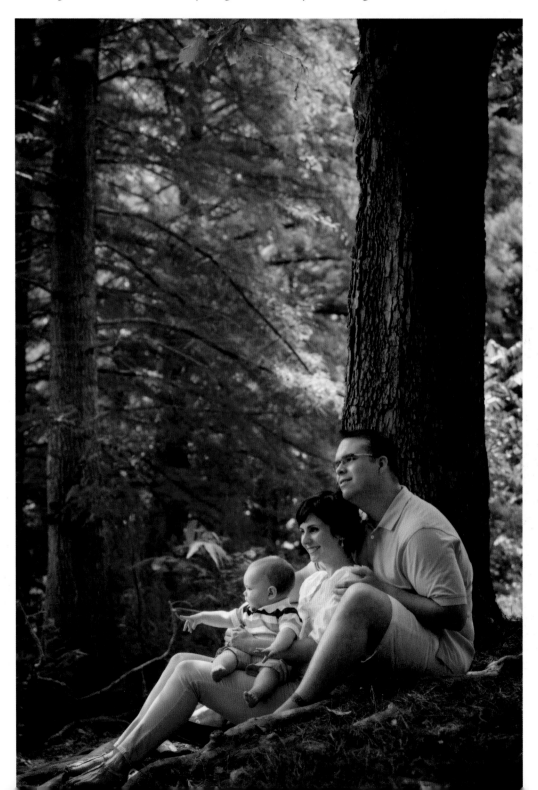

Flowers and Fun

Bluebonnets

These bluebonnet flowers bloom in our area at the end of March and the beginning of April in bright sun. The lifespan of these wildflowers is two to three weeks. Unfortunately, they do not grow underneath trees where the diffused light can often be found, which is what I need for the best photographic results. We have to find new patches of bluebonnets every year; sometimes hav-

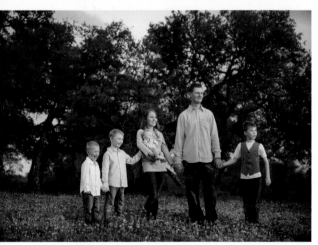

ing to ask permission to use the fields. In years with little rain, the bluebonnets are not as plentiful.

Seize the Moment

I make a list every year of fifteen to twenty families who requested portraits with bluebonnets; our consultation takes place before they bloom, and as soon as they start blooming, I begin making appointments. The sessions are only thirty minutes because the variety of shots in this setting is limited.

The appointments are scheduled in either the first ninety minutes or the last ninety minutes of the day. In the primary image (*facing page*), I used the sun as the main light because it had already gone down behind the bank of trees behind me, giving me a nice soft directional light.

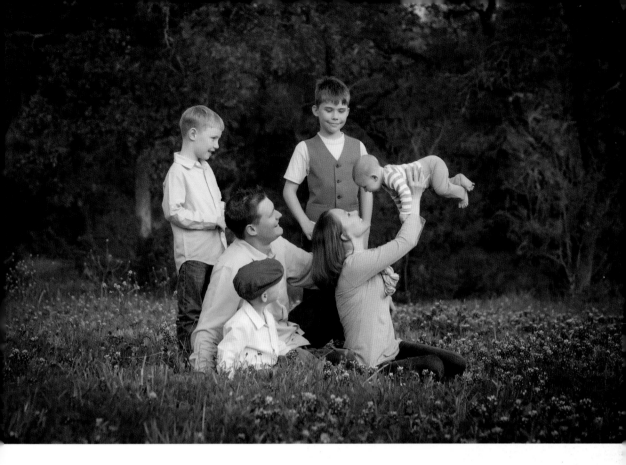

End of Day Sessions with Small Children

One of the problems with photographing at the end of the day with babies and small children is that they are tired. This baby needed to be held by Momma; whenever she lifted him and interacted with him, we got great expressions. Mom holding the baby was a sure-fire way to get the baby to smile.

On the other hand, the older boys liked things that were—for lack of better terms—wild and crazy. To get their attention and reaction, Trey carried on in a slapstick manor. Clowning with physically exaggerated movements is a basic form of comedy and works very well with many young children to obtain delightful expressions that are difficult to get in any other way. Kids like slapstick action and even an Elmo puppet can be part of it.

In the supporting image of the family lined up, the little boy on the left was laughing because of talk about such antics, and he thought it was funny. With children six to twelve years old, uncouth talk often makes them smile and laugh—it is characteristic of the age.

Exposure and Settings

The 70–200mm lens on my Canon 5D Mark III was set at 150mm. My exposure was f/8 at $\frac{1}{200}$ second and ISO 500, using only natural light.

A Special Time at Home

Photographing a Family with a Special Needs Child

The health of Mom and Dad's eighteen-year-old son, who had special needs was failing. And so, it was important to them to

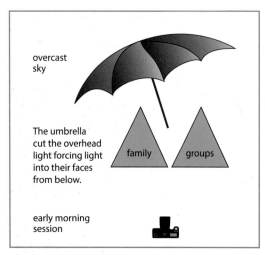

overcast sky

The umbrella cut the overhead light forcing light into their faces from below.

family groups

early morning session

have a portrait with all of their children at this time. We photographed them in December and he passed away in February. He was born with a very rare mitochondrial disorder; it was so rare that there was no record of anyone else having this condition. This family had not been a client and had never had a family portrait. They were friends of a client of mine who requested a favor from me, and I was only too happy to oblige. Trey and I have a special needs child, which compelled me to be there for them and to create beautiful, lasting memories.

Make the Best of Adverse Conditions

It was one of those days where anything that could go wrong did. It was a windy,

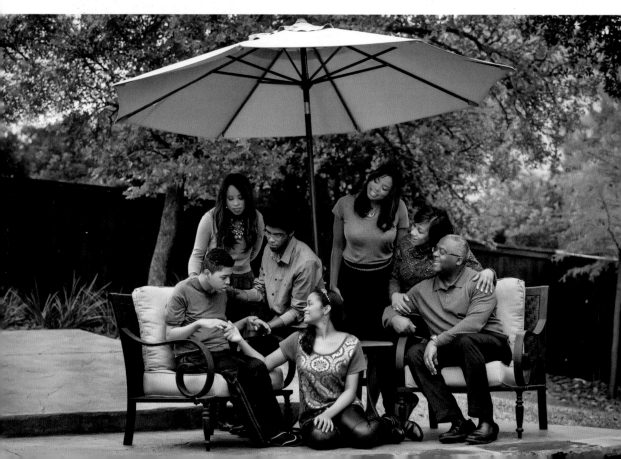

rainy day, and my flash blew over and broke into a million pieces in the middle of the session, leaving me without any auxiliary light. I used the umbrella to cut out the overhead light, forcing light from the overcast, open sky into their faces. The primary photograph of the family with the young man on the chaise lounge (*facing page*) was made with the flash, shortly before it blew over and broke.

The umbrella was necessary to block the light from above, yet still direct the light into their faces, and the young man needed to be seated. I was standing on the other side of their swimming pool with my lens set at 200mm so that I could eliminate the pool in front of me and the houses on the other side of the fence behind them.

Have the Portrait Tell the Story

The primary image was everyone's favorite because it told their story. Music soothed this young man; he had to have an iPad on his lap the entire time as we all listened to the song *Shake It Off* by Taylor Swift over and over again during the session. I removed the iPad in postproduction in the images they purchased.

Exposure and Settings

The primary image was photographed with the 70–200mm lens on my Canon 5D Mark III set at 200mm. My exposure was f/4 at $\frac{1}{125}$ second and ISO 800.

Finding a Great Location

The background for this session was the McNay Art Museum in San Antonio. The grounds are very pretty and the fee to photograph there is very reasonable. When it was free, it was crawling with photographers, but when they began charging twenty dollars, many photographers stopped using the facility. This is a great location to photograph either very early in the morning or around sunset.

Creating Memories

This portrait was created in late afternoon. Mom and Dad wanted a family portrait before their daughter, who was a recent high school graduate, went off to college. It was summer and Mom coordinated the outfits, dressing everyone in shorts and light clothing. In addition to the late day sun for soft light, I also used an off-camera flash that was forty-five degrees to camera left for a little bit of directional light.

Variety in Posing and Composition

The supporting images *(facing page)* are a variation of my primary image *(left)*. I try to mix it up so that the same people are not always sitting on the ground or standing or sitting next to the same person; I am looking to give my clients variety in posing and composition. I also want some images that are close up and some from a

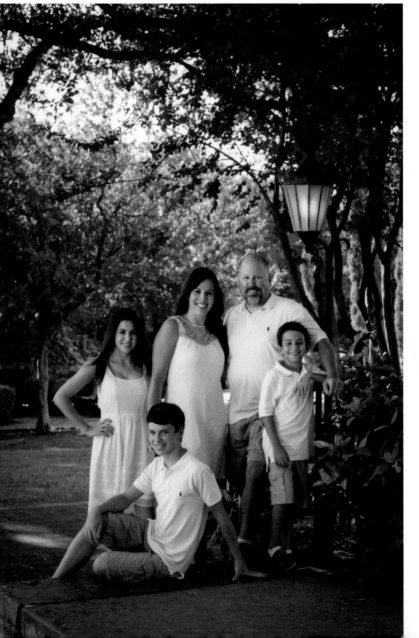

distance so that when they are viewing the photographs, they have many options.

Working with Children

Generally, when I photograph a family in which the youngest child is nine or older, I work without an assistant because the child is old enough to follow my directions. I focus all my attention on the youngest child to achieve a natural expression; I will talk about his sister's boyfriend or Mom and Dad's stinky feet, or I will bend over to take the photo and exaggerate my body position, clowning in a very big way—all of which get a good smile from the family. I prefer a natural smile and expression by making them laugh through my antics rather than asking them to look at me and smile.

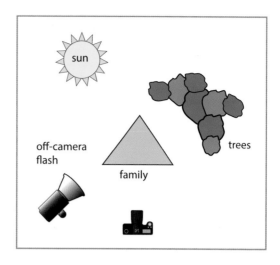

Exposure and Settings

The 70–200mm lens on my Canon 5D Mark III was set at 75mm. My exposure was f/6.3 at $\frac{1}{160}$ second and ISO 640. I used an off-camera flash, forty-five degrees to camera left.

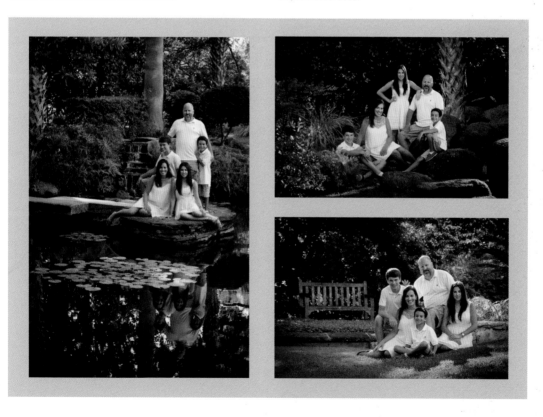

Cultivate Premiere Clients

This family is one of my premiere clients that come to me every year. I have been photographing them since their oldest child was born. They have also been on some of my destination portraits sessions; we have

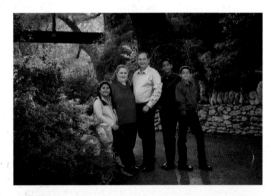

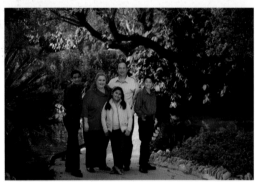

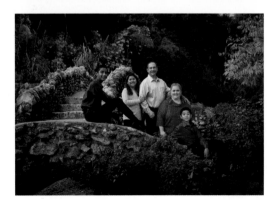

been to Hawaii and Italy together. They are a fun family, but they can be a challenge. Dad is very strict and wants them to sit up straight and tall. However, for the portraits I want them to appear more relaxed by bending a leg or putting their hands in their pockets. I have to re-train them whenever I photograph them because they are so used to standing at attention.

Posing Larger People

Mom wanted the bright colors for this portrait. My goal is to flatter everyone and to make Mom look her best. When working with a subject that is not as thin as those around her, the objective is to partially hide that individual in all the images, which helps to decrease his/her size. Instead of having Mom in front and center focus, I always place others in front of her. Do I tell her that I minimize proportion through placement? No, but I want to make sure that Mom is always one hundred percent happy with the way she looks in the photographs.

Popular Settings Can Change

The waterfall behind the family is a very popular backdrop, and many of my clients want me to photograph them in this area. However, when our rainfall is diminished, the waterfall may be turned off, which can create a problem.

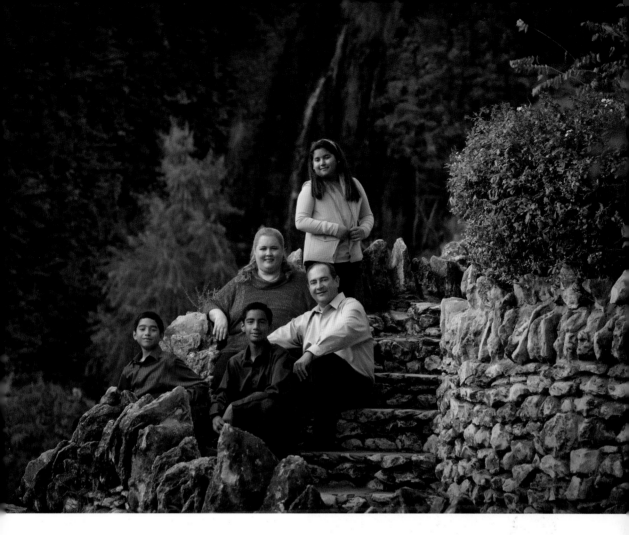

Being Gross Evokes Expressions

This family gets great pleasure in seeing our self-deprecating humor. To evoke expressions from them, Trey will do something that looks like it would provoke me. Usually the humor is very base. Trey gets these kids to laugh by purposely acting slightly unprofessional and doing some things that might make your mother cringe.

Exposure and Settings

The 70–200mm lens on my Canon 5D Mark III was set at 130mm. My exposure was f/5 at $\frac{1}{320}$ second and ISO 640.

Know to What the Child Will Respond

This is a very sweet family, and the little girl is a dynamo. We evoked her facial expressions as she responded to Trey's more

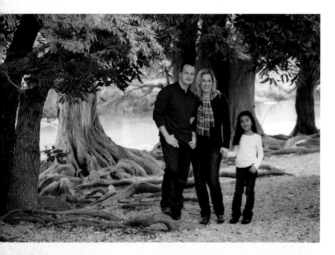

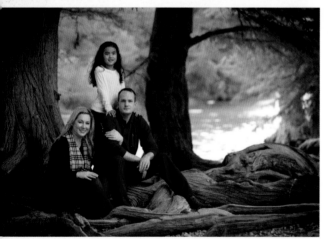

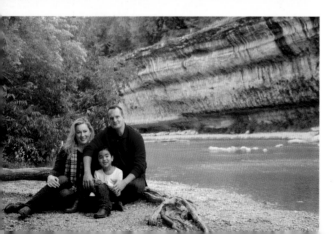

pugnacious routines. Each child is different as to what will make them smile. The great thing about photographing a family over and over again is that you really get to know who they are. We know what this young lady likes, so we know how to evoke the best expressions. When we are working with a child for the first time, the first fifteen to twenty minutes is spent trying to figure out what the child will respond to. This session was done on our Fall Family Day at the Guadalupe River at 10 AM. I am very familiar with the area, so I know where the sun is throughout the day.

Vary the Posing and Locations

I sometimes have the family looking at the camera first and then looking at my assistant, so their faces are visible, especially for the gift portraits for the relatives. However, I also do an interactive pose; I just love the little girl's expression, looking up at her parents, so sweet. As can be seen in the supporting images, we moved to different locations for a variety of backgrounds as well as a variety of poses and expressions. I used a number of focal length lenses for this session because of the varied locations.

A Natural Foundation

The tree growing diagonally to the right gave us a foundation for this pose. I try to look for anything in nature that will give

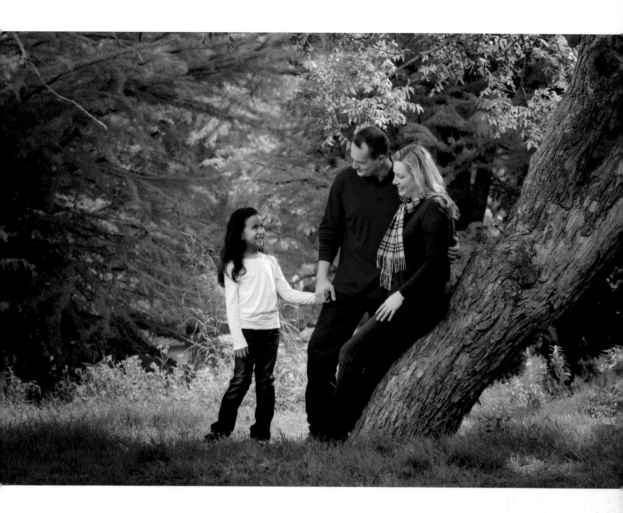

me posing options and levels so that I can have my subjects sit, stand, or squat. I want a variety of positions in the images, rather than everything being entirely standing poses. The tree worked perfectly as a base and support for Mom.

Exposure, Lighting, and Settings

The 70–200mm lens on my Canon 5D Mark III was set at 100mm. My exposure was f/7.1 at $\frac{1}{200}$ second and ISO 320. The sun was high in the sky, somewhat behind the family, and above the trees on camera right. I used a silver reflector, at approxi-

mately forty-five degrees to the left of the camera, to bounce light back into their eyes and faces.

| # Majestic Mission Door

Mission San Jose

The Mission San Jose in San Antonio is the largest of the five missions in city. It is a working church, and it has wonderful arches and great architecture. These hand-carved doors are gorgeous, but there are a lot of rules. The custodians are very protective of everything about the mission.

Planning Consultation

The purpose of my planning consultation prior to a portrait session is to understand the client's objectives and where they want to be photographed. I have many family portrait samples photographed at this mission, so many families come to me specifically to be photographed at this location. This family knew that they wanted to be photographed at the Mission San Jose before they came in for the consultation.

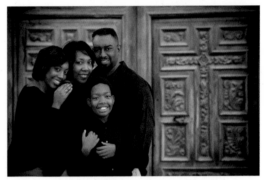

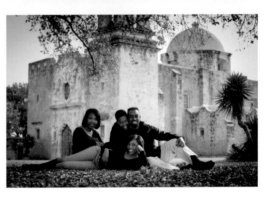

Know Your Location

This location offers a variety of areas where we can work. I photographed them within the Aisle of Arches, which has a beautiful repetitive design with a rock-pebbled floor, as well as using the whole mission as the

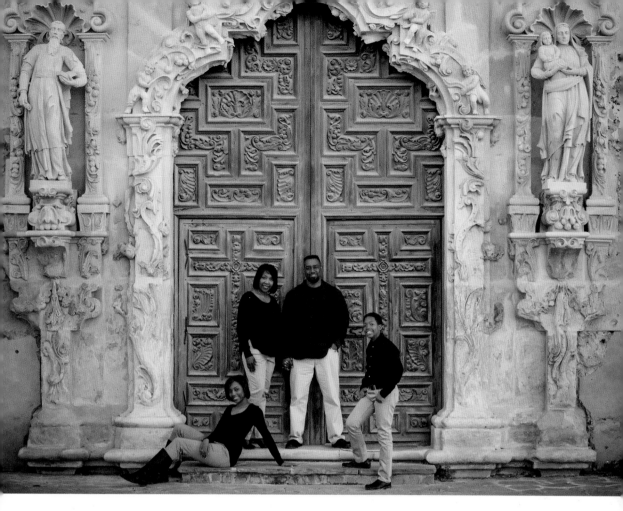

background. Every place you turn in Mission San Jose has a beautiful setting; it is all a matter of choosing the day, time, and what area is to be the principal focus for the portraits. Because we were going to be photographing in the morning, I knew that this side of Mission San Jose, with the beautiful doors, would be ideally in shade.

Composition

This pose was made based on the conversation that I had with my clients at the consultation; they were interested in a 50-inch portrait above their living room couch. I wanted to create a portrait that had a lot of space; if I had to crop tightly, where would I cut off these magnificent doors? This was the perfect composition.

Exposure, Lighting, and Settings

The sun was behind the mission and I had a lot of open sky. However, I did use an off-camera flash, approximately forty-five degrees to camera right, because there was not a lot of directional light at this time of day. I used this added light to get a little extra kick of light into their eyes.

The 70–200mm lens on my Canon 5D Mark III was set at 70mm. My exposure was f/5.6 at $\frac{1}{125}$ second and ISO 400.

Communication

Our high school seniors are added to a mailing list so that we can continue to communicate with them. For this family, the younger daughter was a high school senior, soon to leave home. This was to be their last family portrait before both girls were out of the house. Communication is important, which is why we send out a newsletter three times a year.

Be Prepared for Last Minute Change of Venues

They were scheduled to be photographed on a Saturday at the San Jose Mission, but it was raining very hard. Although we rescheduled for the next day, the weather never cleared. Because the oldest daughter was only going to be home from college for the weekend, this was our only moment. We promptly switched gears on Sunday, and I photographed them in their home. Sometimes you have to play with the cards you

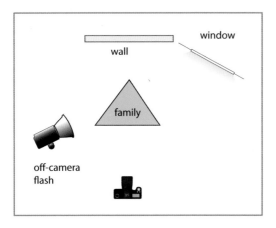

are dealt. Fortunately, their home is spacious and beautiful. I photographed them in their living room. They were lit by an off-camera flash almost ninety degrees on camera left and by the ambient light coming from the window behind them on the right as a fill light for balance.

When photographing in a home, I want to show the environment and not place the subjects in a corner of a room. I sometimes have to move items around so there are no objects growing out of people's heads, but in this instance, everything was fine.

Secondary Images

The secondary image *(top left)* taken in their hallway worked well, even though it was a confined area. The window on camera left gave me the light I needed. There had

been a large mask on the wall behind them that was looming down over them, distracting and intersecting Dad's head. It was heavy and not something that they wanted taken off their wall, so I removed it later in Photoshop during postproduction.

The photograph of them in their dining room *(facing page, bottom)* depicts their travels, with their favorite vineyard painted on their wall from a photo they had taken in Tuscany, as well as the glass on the table that they had purchased in Italy. All of the colors worked well with the color scheme of their clothing.

Exposure and Settings

The 17–35mm lens on my Canon 5D Mark III was set at 30mm. My exposure was f/5 at $\frac{1}{160}$ second and ISO 400.

My Client, Her Patient

This is my eye doctor and her family; before she was my eye doctor, she was my client. She wanted to do something old fashioned and dressy in a not so old fashioned, dressy place. This image was created in the fancier section of our local botanical gardens, which for the most part, is a casual and rustic place. She dressed the boys very formally in their suits, and she wore this beautiful full length lace dress. Because of their formal attire, most of the poses were of them standing; however, I did have them sit on a bench in a few of the images near the end of the session. She wanted primarily serious looks, but she wanted smiles as well, so I mixed it up for her.

Trey and His Bag of Tricks

Trey evoked the boys' expressions with his usual bag of tricks. He has squeaky

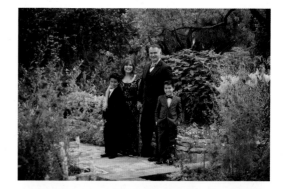

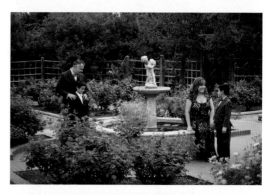

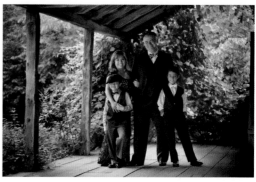

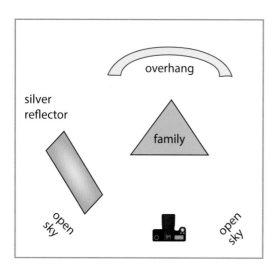

props like plastic hammers that reliably get instant laughs and made these boys smile and giggle. He also used a tickle feather and a rubber chicken that made an awful squawking noise as he wielded it in a goading manner. We will do any type of silly,

stupid thing to make the kids laugh. Our antics also made Mom and Dad laugh very hard; even professional people laugh at silly things. I sometimes had to rein the parents in because they were laughing too hard, unable to believe that two mature adults were making fools of themselves. However, I find that professionals appreciate the fact that we go above and beyond to capture the necessary expressions. One of the reasons that we have so many repeat clients is because of the way that we work with the kids, and that we try to make it effortless for the family.

Photographing for an Album

The secondary image of the family divided by the fountain *(middle left)* is a good example of why clients purchase an album. I think about the concept of an album while I am photographing a client. This portrait was designed for a panorama across two pages. I intentionally posed them leaving the center open for the fold in the page.

Exposure and Settings

The 70–200mm lens on my Canon 5D Mark III was set at 150mm. My exposure was f/8 at $\frac{1}{125}$ second and ISO 400.

Generational Portraits

I enjoy creating generational photographs; I think it is awesome that they have four generations to make this portrait. This image is going to forever be a part of their family history. When this little baby grows up, she is going to cherish this portrait of her with her Mom, Grandma and Great Grandma.

A Short Window of Time

My bluebonnet sessions are photographed only during a two-three week period while they are in bloom. I schedule the appointments in thirty minute increments and will usually do two or three a day. This was my first of the three portraits on that day; it was still early and the sun was still high in the sky, so I was able to create a nice available light portrait.

Bring the Necessary Props

I brought the chair with me because I knew that Grandma could not sit on the ground and I did not want her to have to stand in every photograph. The chair served as a base for the portraits as I moved people in and out and around it. The other portraits were more interactive, showing the flowers to the baby, who just wanted to eat them, as well as the four ladies, showing the succession from oldest to youngest. Even in a thirty minute session, I try to do as many different combinations as I can because it gives the client more opportunities to

purchase photographs, either for gifts or for an album. I do not charge extra for all of the different breakdowns, because it is as important to me as it is to my client.

Positioning

I posed the group left of center, following the rule of thirds. I wanted to be sure that the Grandfather's head was completely enclosed in the trees and not in the white of the sky. I also did not want the tree behind Great Grandma growing out her head.

Exposure, Lighting, and Settings

The 70–200mm lens on my Canon 5D Mark III was set at 130mm. My exposure was f/8 at $\frac{1}{250}$ second. This was taken early in the afternoon, so I used the sun and open sky with a silver reflector at almost ninety degrees to camera left, bouncing the light back into their eyes and faces.

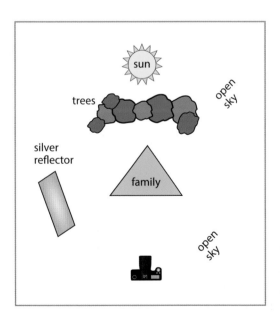

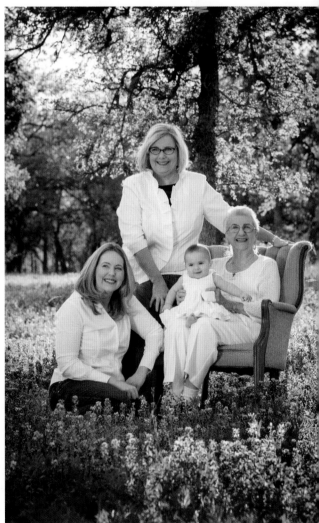

NYC Bright Lights, Big City

Explore New Venues

This was my first portrait session in New York City. This family is one of our premiere clients who we photograph often, and they wanted to have us create a portrait for them in the Big Apple. We talked about it for a few years, finally decided on a date and we all flew north.

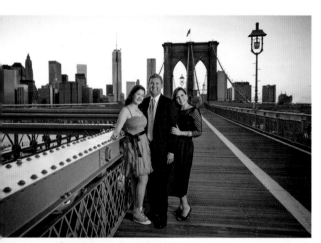

Good Weather, an Agreeable Teenager, and Numerous Locations

The young lady was fourteen years old at the time, very agreeable and easy to pose. Luck was with us because this was a beautiful day in August, not too hot or muggy, as it can sometimes be in New York. Mom had been there many times and knew exactly where she wanted to be photographed. We worked at five or six different locations, but this was the spot for the special portrait at the end of the day. We wanted the lights of the city to be on, so we were here right at dusk, and we stayed as it got darker.

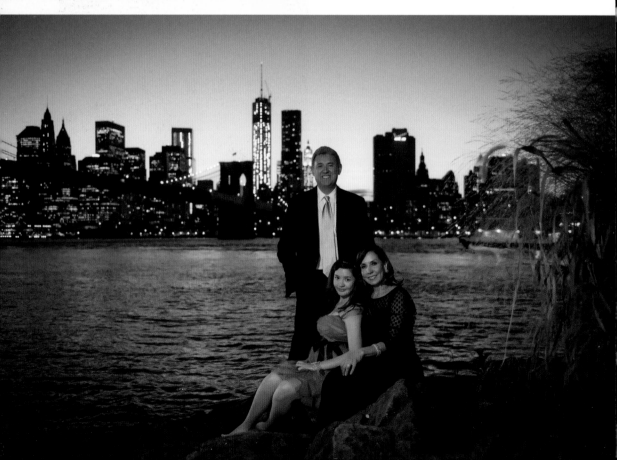

We started in Central Park, followed by going to the Brooklyn Bridge, where we almost got run over by bicyclists. Our next stop was Grand Central Station followed by a few more locations after that. Mom's concept was for them to be in fancy clothes with the New York skyline and the Brooklyn Bridge at dusk in the background. This was the goal and the other images were the gravy. A 40-inch canvas of this image is proudly displayed in their house.

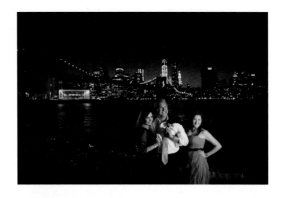

I took advantage of this being my first portrait excursion to New York City and also photographed a ballet dancer at sunrise on the streets of New York.

Exposure, Lighting, and Settings

For this image, I used two different light sources; in addition to the setting sun, I used an off-camera flash, approximately forty-five degrees to camera left. The 28–70mm lens on my Canon 5D Mark III was set at 50mm. My exposure was f/5.6 at $\frac{1}{60}$ second and ISO 800.

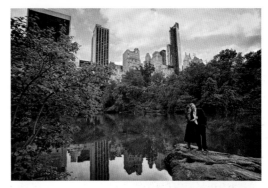

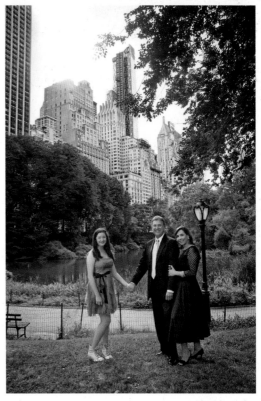

Relationship Portrait

Tim Walden coined this kind of portrait image a *Relationship Portrait*, and often photographed them in black & white. I photograph them in color as well as black & white. The purple/blue tones of their clothes went very well with the oranges and reds in the background.

Getting the Baby to Sleep

Whenever we photograph a baby that is four months or younger, the baby may be wide awake in some of the images, but we also try to tire them out so that they fall asleep. This family wanted the baby to be asleep; when we photographed the big sister three years earlier, she slept through the entire session. They wanted something similar so that the two portraits could be displayed together on their wall. I used a white noise machine that not only helped the baby fall asleep, but also kept the baby from waking up from a sudden noise in the room. It was a great investment, and I believe it is now available as an app for most cell phones.

Tricks for Little Children

The baby fell asleep and the big sister was wonderful to work with. One way to keep a three-year-old entertained is with bubbles. My assistant was on camera left blowing bubbles, which amused the little girl. For this image, with the infant asleep,

my assistant had the little girl looking right where we needed to with a perfect expression because of the bubbles. Sometimes when we have a three- or four-year-old close their eyes, it looks forced. In the supporting

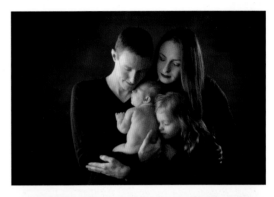

images, I had her look down at Daddy's fingers, and it looks like her eyes were closed.

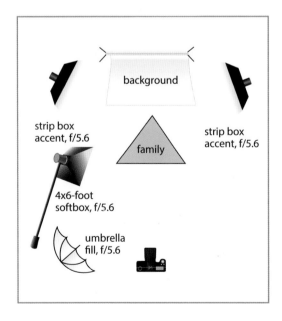

Lighting the Subjects

My studio lighting for this portrait consisted of an umbrella fill, forty-five degrees to camera left, and a softbox approximately ninety degrees to camera left. I also used two strip box accents facing toward the family from behind them, giving me a slight rim-lighting effect. There was no light aimed at the background; the background was illuminated by the falloff from the other lights.

Exposure and Settings

The 70–200mm lens on my Canon 5D Mark III was set at 110mm. My exposure was f/8 at $\frac{1}{125}$ second and ISO 125.

23 | Family Traditions

Portraits with Meaning

I have been photographing this family for a number of years. It was the holiday season, and they wanted a family portrait with their baby daughter at their home that was decorated for Christmas.

 This was a lengthy session; I photographed all of the kids individually and together, the parents together and separately, as well as the whole family. About half-way through the session, I asked if they had a family Bible, which, because Dad is the son

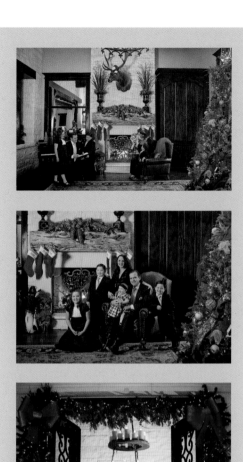

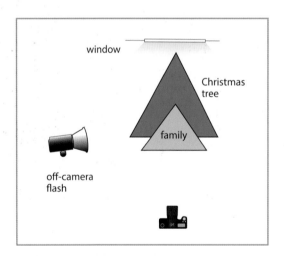

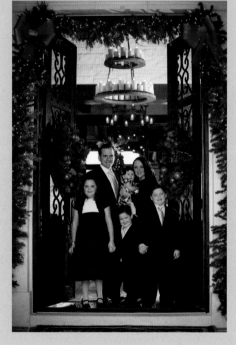

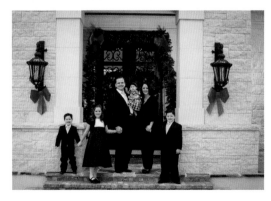

of a pastor of a very large church in San Antonio, they did. The giant Bible was perfect for the portrait. I posed them with Dad in the center, reading the Bible as they all huddled around him. This was storytelling; this is who they are, this is what their life is about. Not only is the Bible, which has been in the family for generations, special, but the fact that he is reading it to his wife and children gave this image impact, especially for them. They purchased a 50-inch painted canvas, which looks stunning hanging in their home.

Lighting and Exposure

This was photographed with an off-camera flash, approximately ninety degrees to camera right. Often a baby can be distracted by us, but in this instance, she was more interested in reaching out to turn the page of the Bible, which fit nicely in the theme of the story.

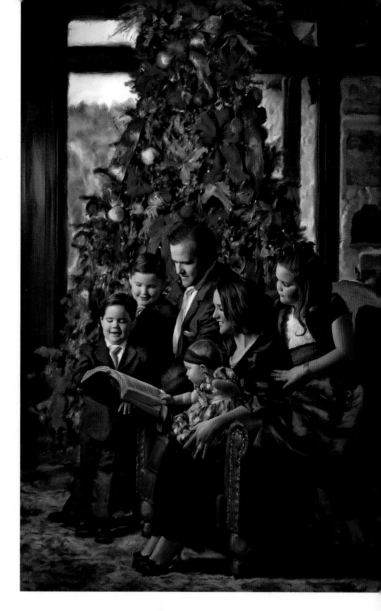

Photograph for Variety

The other images helped to show Christmas time with this family, which is very important to them. We also created a few images outside on their porch for variety; they also purchased the photo of them standing in front of their door with the candles behind them, as well as a collection of photographs of the children alone and together in front of the door. With most of our clients, we sell a wall portrait or perhaps more than one, but we also sell collections and albums so that they can enjoy all of the photographs we created.

Exposure and Settings

I was standing quite far from them, with the 70–200mm lens on my Canon 5D Mark III set at 160mm. My exposure was f/5.6 at $\frac{1}{60}$ second and ISO 640.

Creating Memories from Special Moments

This family and these young women have been clients of mine for many years. This latest family portrait was orchestrated because the younger daughter was soon to go off to college and their family dynamics were going to change. This was going to be Mom and Dad's last hurrah before they became empty nesters, and they wanted a large vertical canvas for their wall.

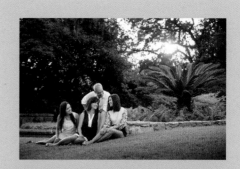

Designing the Session

We have a design consultation before every family portrait session. This is our chance to discuss everything we have to offer and to find out what they are looking for. I cannot imagine going into a session without knowing what our desired finished product is going to be; most of our "selling" happens during the consultation. If we had not discussed where they wanted to display

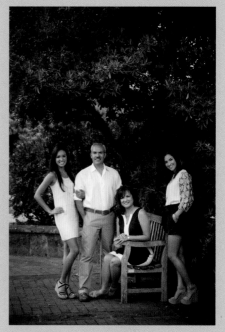

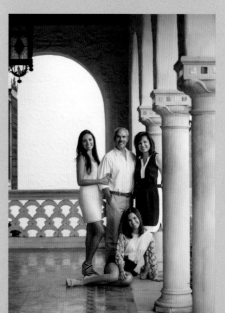

their portrait, I may not have created a vertical image. It would have been a shame if all the family images I created were horizontal, leaving me missing out on that large wall portrait sale.

Composition

The composition of this portrait was enhanced by being able to utilize the steps as levels so that everyone was standing at different heights. I was able to pose the younger daughter diagonally as she sat on the second step, leaning back on the top step. This placement gave the image some weight to the bottom of the image. The repeating vertical pillars of the arches mimic the shapes of the parents and the older daughter, who are posed vertically.

Lighting and Camera Information

The sun was setting on camera left and the highlights from the sun are visible on Mom's hair and the back of the hair of the daughter who is standing next to her. There was no overhang for them to stand under, but they were standing next to a wall, which with the sun and the added reflector, gave me great light on their faces.

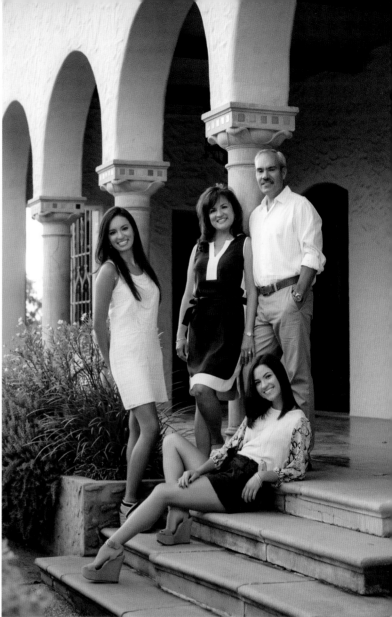

Exposure, Lighting, and Settings

This was photographed with the 70–200mm lens on my Canon 5D Mark III set at 150mm. My exposure was f/5.6 at $\frac{1}{125}$ second and ISO 400. This was photographed later in the day, nearing sunset. The only light used was the setting sun and a silver reflector positioned forty-five degrees to camera right.

Portraits Made in the Home Have Special Meaning

I love creating portraits in my clients' environment; these photographs have a special meaning to the family. Beyond capturing a moment in time, we are capturing that special moment in their surroundings. They will cherish it more than a portrait made in my studio or in a park because after the children are grown and leave the nest, they will always have the memory of the house where they grew up.

This image was photographed in front of the clients' house; my assistant was as close to them as possible without being in the photograph. The goal was to capture their portrait while showing their home in the background. Family portraits are often photographed in a horizontal format, but in this instance, Mom requested a vertical format for the photographs.

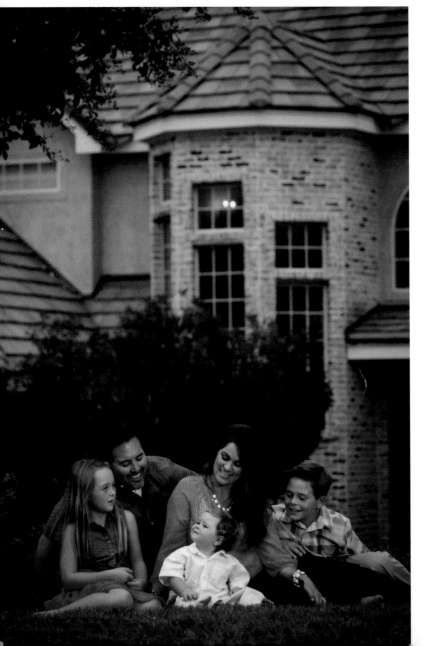

A Star Was Born

The little boy is the star of the family; Mom and Dad really wanted another child, and the older siblings adore him. The baby was very expressive, and therefore, easy to work with. While everyone was looking at him, he was looking up at Dad, or so it appears. In reality, my assistant is who the baby was looking at, as he was on the left just outside of the camera's field of view.

Think Outside the Box

Some of the images were created with an album in mind. The photo of Mom and their daughter on the left and Dad and their sons on the right with the fountain in the middle was composed for a two page panorama spread. The photo of their daughter kicking the water is an example of some of the fun images that I created during the session. This was near the end of the session, and I always try to do something fun for the kids so that they have enjoyable memories and pleasantly anticipate our next session.

Exposure, Lighting, and Settings

This was photographed with the 70–200mm lens on my Canon 5D Mark III set at 140mm. My exposure was f/5 at $\frac{1}{125}$ second and ISO 400. The sun was behind clouds in back of my subjects on camera left, and I had a lot of open sky. I used an off-camera flash forty-five degrees on camera right for light in their eyes and faces.

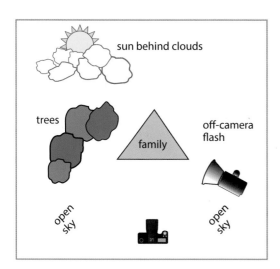

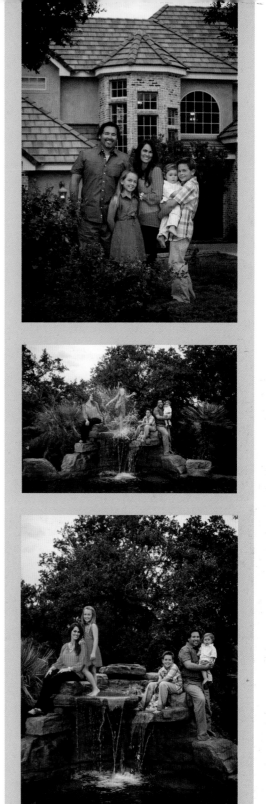

By the River Bank

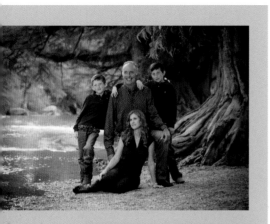

The Environment as a Posing Tool

The roots of the trees are really amazing, and importantly, they offer several levels to pose the subjects. They also add a texture to the image. This location is very picturesque, and the shade is perfect for indirect lighting. The roots are not always the most comfortable place to sit because of the odd shapes and angles, but they intrinsically place everyone at different levels. I simply cannot let them sit there too long because of the discomfort. Whenever I pose my clients in any situation, I try my best to not have them pose in one spot more than five minutes before I change the pose or move them to another location so that they do not get uncomfortable.

Know the Contemporary Lingo

My only difficulty with this session was in drawing a natural smile from the boys. We had to work a little harder to evoke the best expressions. However, I knew we could win them over. I had Mom and Dad look at me with my assistant standing right behind me, ready to give me a "wet Willie;" this always makes the kids—and the parents—smile. It is important to keep up with current youthful trends, expressions and lingo because they change regularly. "Awesome" is out; "boss" is back. Sometimes we have to be dorky to get the expressions we want, and we have found that in some instances, we have to milk this dorkiness for all it is worth. Boys this age will react to anything that is goofy and kind of stupid; they think it is hysterical and engaging.

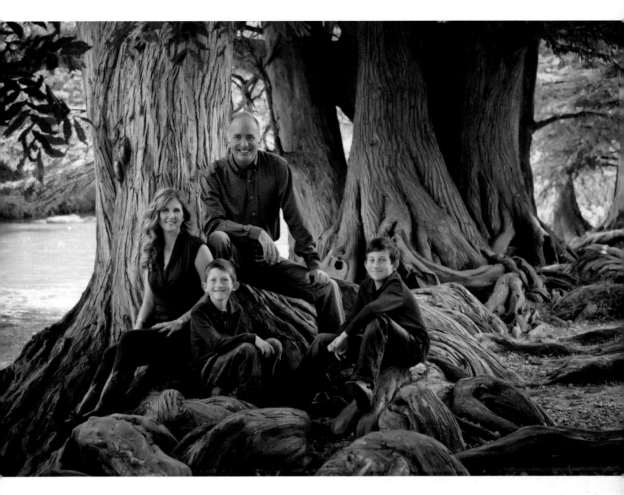

Exposure, Lighting, and Settings

This image was photographed by the Guadalupe River with natural light and a 70–200mm lens on my Canon 5D Mark III set at 70mm. My exposure was f/5 at $^1/_{100}$ second and ISO 250. The main light was hitting the rocks to my left, which is where I placed my silver reflector, approximately forty-five degrees to camera left, bouncing light back into their eyes and faces.

Backyard Party

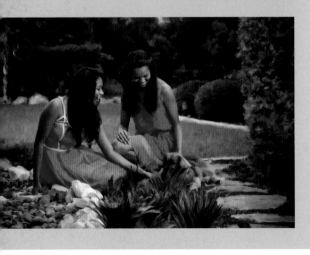

Sometimes You Cannot Reschedule

This portrait was created in the clients' back yard on an overcast, rainy day. Mom had landscaped every inch of the yard, paying close attention to detail. She really wanted to show off her family, her yard and her hard work. The girls were home from college, and we had to photograph them on this rainy day because there was no other opportunity. We could not reschedule due to time constraints. We just went ahead with the session. It never really rained hard, but it was not the best weather day. Fortunately, they were real troupers. It was also important to have their dog in the portrait because he was very much a member of the family.

Hawaiian Flair

Mom is from the Philippines and one of her favorite places is Hawaii; she wanted to

bring that Hawaiian flair into the image, which was why everyone is wearing bright color tones and she was wearing a flowered dress. While their clothing may not have worked for others, it really worked well for this family in this particular setting.

Clothing Changes

They changed their outfits a few times, which I typically do not recommend; however, we were at their house and I knew that it would be done quickly. I also knew in advance that she wanted a large canvas grouping of this session, so the variety in clothing would add to the portraits. Her complete purchase consisted of a series of nine canvas wall portraits for her fifteen foot wall, which Trey and I hung for them.

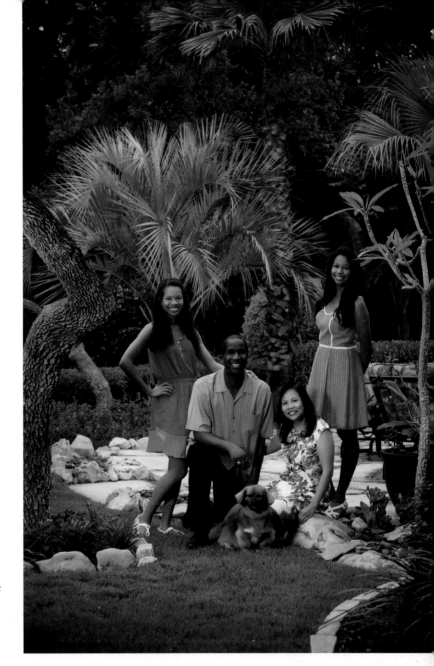

Exposure, Lighting, and Settings

This was photographed with the 70–200mm lens on my Canon 5D Mark III set at 200mm. My exposure was f/5.6 at $\frac{1}{160}$ second and ISO 800. Because the light from the sun was not very strong and the day was overcast, I had to add an off-cam- era flash, approximately forty-five degrees to camera left, to get the light in their eyes and to punch up the colors in their clothing.

Family in Red

Using a Natural Background

There is a wall that goes around Mission San Jose; part of the wall is in ruins and a section of it still has big doors that enter into large rooms so that the public can see where the people slept and cooked. Some of the doors *(facing page)*, like this one, are closed, which makes for a nice backdrop, and what remains of the awning is still there, adding to the décor and feel of the mission setting. It was cold that morning, and they were huddling and cuddling together for warmth.

Secondary Images

The image of the family inside the mission's portico with the little girl sitting on the small wall *(bottom middle)* was lit with the natural window light on camera right and a door on the left. I also photographed them in the Aisle of Arches, as well as in the doorway, with the family just beyond the overhang *(bottom right)*. This is one of my favorite spots at Mission San Jose, but this doorway is more for an interactive image,

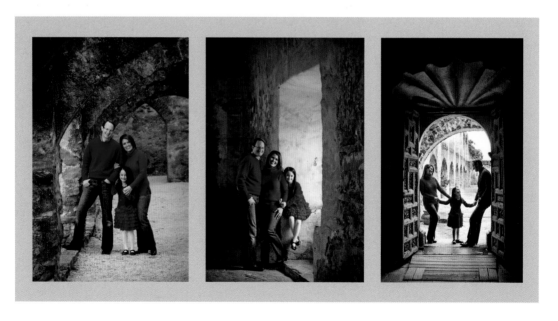

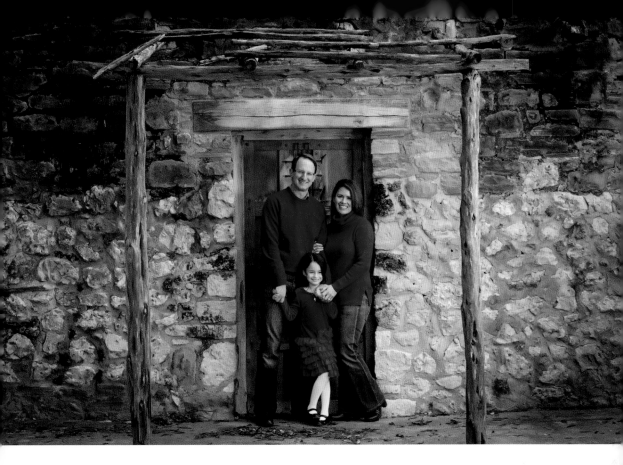

not a smiling, looking-at-the-camera pose. I make sure that my clients receive a variety of poses in addition to the family portrait: the daughter by herself, Mom with her daughter, Dad with his daughter, Mom and Dad together, and individual portraits of Mom and Dad. This gives them the opportunity to purchase wall groupings or an album showing all of the different poses I have created.

Holiday Portrait Special Sessions

This was part of my Holiday Portrait Special, which was photographed at Mission San Jose around Thanksgiving and again around Christmas. The one-hour sessions are photographed throughout the day, and because of the way the mission was built, there is always shade in some area. Some areas may not look good at certain times of the day, but I can always find a spot where we can create beautiful portraits.

Exposure, Lighting, and Settings

The primary image *(above)* was photographed with the 70–200mm lens on my Canon 5D Mark III set at 70mm. My exposure was f/8 at $^{1}/_{125}$ second and ISO 500. The sun was behind clouds and the family on camera left; I used an off-camera flash on this overcast day, approximately forty-five degrees to camera right, to add a little light into their eyes.

Architectural Surfaces

These images were created at Mission Concepción, which was dedicated in 1755, and appears very much as it did more than 260 years ago. In its heyday, colorful geometric designs covered its surface, but the patterns have faded or been worn away.

Photographing an Active Child

This session was difficult because the little boy would not sit or stand still; Mom was hugging him on her lap in order to keep him in place. In the other photos, he is holding onto his sister's hand and being held by Dad; it was the only way to keep him where we wanted him. Trying to get his attention and keep him in one place was our biggest challenge. Mom, Dad and their daughter were great. We only had to worry about the little guy who was going ninety miles an hour. We found that the only way

to get his attention was for Trey to be loud and surprise him with whatever we were doing. Then he would stop, look, and process it, which gave me a few seconds to capture an image before he ran off again. In order to grab his attention, we had flying contests with Elmo, Big Bird, and Cookie Monster, throwing them up in the air and putting them on Trey's head. We did whatever it took, getting his attention for a few seconds, in order to capture an image. I would instruct Mom and Dad to look at Trey, just laugh, and to absolutely not look down at their son—which is what parents tend to do. That way, when their son was ready, everyone would be looking in the right direction with pleasant expressions, and I would be able to make the exposure in a timely way.

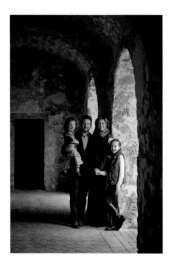

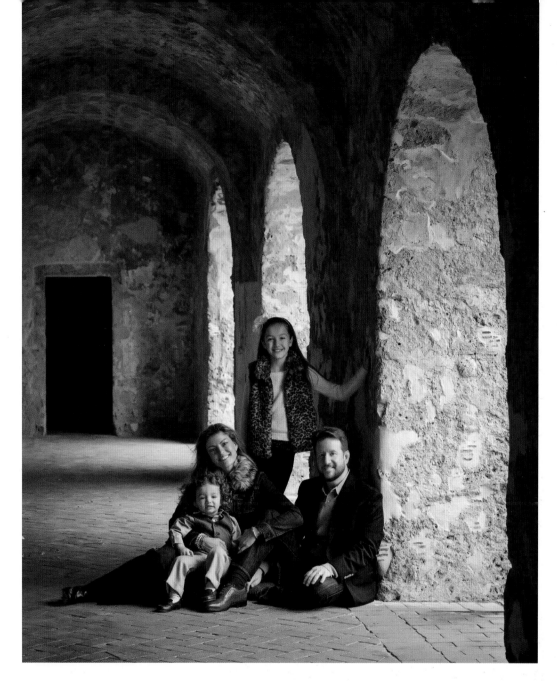

With the photo of the older sister hold-ing the little boy's hand, my assistant was outside the door blowing bubbles to gain his attention; he was there long enough to capture this image. In the photo where Dad is holding him, he was very wiggly because he did not want to be held.

Exposure and Settings

The primary image *(above)* was photo-graphed with the 70–200mm lens on my Canon 5D Mark III set at 110mm. My exposure was f/5.6 at $\frac{1}{125}$ second and ISO 800.

Clothing Guidelines

I never like to tell people what to wear, but I do give my clients guidelines. Everyone has an idea as to what clothing expresses their personality, so it is not for me to tell someone not to wear patterns—although my suggestion would be to wear a subtle pattern. I discussed clothing with this family, and this patterned dress was what she chose to wear. It is a busy pattern, and my attention is drawn to her dress, but she liked it, and that is all that matters.

This photograph *(facing page)* was taken at the San Antonio Botanical Gardens on the porch of a cabin with a roof over their heads and light coming in from three sides: behind the camera, from camera left and from camera right. I also used a silver reflector on camera left to help bounce light back into their eyes. The cabin behind them, which dates to the 1800s, is a popular location, and many families like to be photographed here.

Creating Levels

I created my levels by placing Mom on the floor of the porch and having Dad hold their baby in his lap, while the little girl is standing on the right holding Dad's arm. The baby was happy as can be, easily amused and gave us great

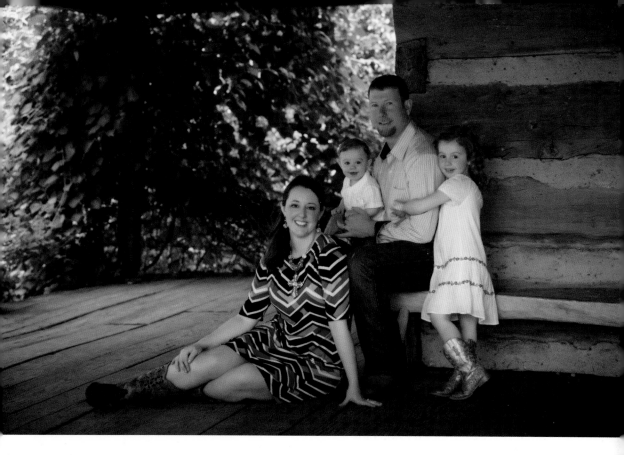

expressions. Their daughter was very proud of her cowboy boots, and I had to be sure that they were visible.

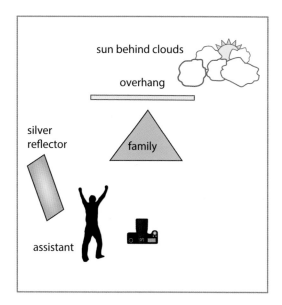

Children Should Be Rested and Fed

These children were wonderful, but not every parent thinks about nap time or is concerned with rest and eating schedules. Photographing a child after a nap and being fed is usually much easier than trying to photograph one who is tired and hungry. A tired or hungry child is not a happy child, so be sure to raise this important point during the consultation to ensure that you have a successful session.

Exposure and Settings

The primary image was photographed with the 70–200mm lens on my Canon 5D Mark III set at 80mm. My exposure was f/4 at $\frac{1}{125}$ second and ISO 400.

Skipping Rocks by the River

Early Morning Light

I created this family portrait (*facing page*) before the sun rose over the cliff, which was out of view on camera left. I used only the early morning open sky for light, without the aid of any off-camera flash, and it gave me beautiful, soft, directional light.

Let Kids Be Kids

Their son was energetic, but he was great during the interactive poses. He wanted to throw a rock into the water, so we took a break and let him do it. I believe that you have to allow the kids to do what they want to do so that they will also do what you want them to do. It may not always work, but it does often enough. This pose (facing page) is one of my favorites because it was so natural; he was doing what kids do. If you want to have the child looking at you and smiling, you sometimes have to take

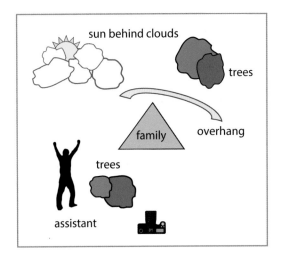

breaks every once in a while and give him a reward for being good. This was probably half-way through the session, and even though it was a break to allow him to throw the rock, I was still capturing what was happening; it was a break for the child, but I kept working.

Fun Poses

The photograph of Mom and Dad swinging their son *(top left)* is another fun pose that kids this age love; they love to walk with their parents and then be swung, "one, two, three, weeeeeeeeeeeee!" They did this a few times so that I could make sure everyone was sharp and in focus, and that I was able to capture good expressions. This was not really posed. They walked and swung him as I photographed them while it happened. Every time they put him down after swinging, he would call out, "More! More!"

Another popular pose, especially if the client is going to purchase an album, is like this one with their son in the foreground, and Mom and Dad soft in the background *(bottom left)*. He is the center focus, and the parents are looking on at him.

Exposure and Settings

The primary image was photographed with the 70–200mm lens on my Canon 5D Mark III set at 150mm. My exposure was f/5 at $\frac{1}{125}$ second and ISO 400.

Multi-Generational Portrait

This multi-generational portrait *(below)* featured the nucleus of the family, including Mom's two sons, one daughter, and her grandson. Some of the images were of Mom with just her children, while others also included her daughter-in-law.

I photographed them by our pond in the back on our studio grounds, which is located within the 2.5 acres of our property. This portrait was initiated by the family with the little boy; they are excellent clients, and we have photographed them numerous times over the years. They wanted to do something a little bit different, so they chose to be photographed in purple, which is Grandma's favorite color. It might not be the right color for everyone and everything, but it goes well with the spring feeling we were trying to convey.

Discards Can Wind Up in an Album

The fun photograph where the uncle picked up the little guy and turned him upside-down may not be a perfect photograph, but everyone, including the little boy, enjoyed the activity. This was one of their favorite poses because it captured a fun moment and something the uncle does often. Do not be afraid to show your clients some of the photos you originally thought to take out, because they may wind up in an album. This photo was an outtake, but fun nevertheless, and included in their final album choices.

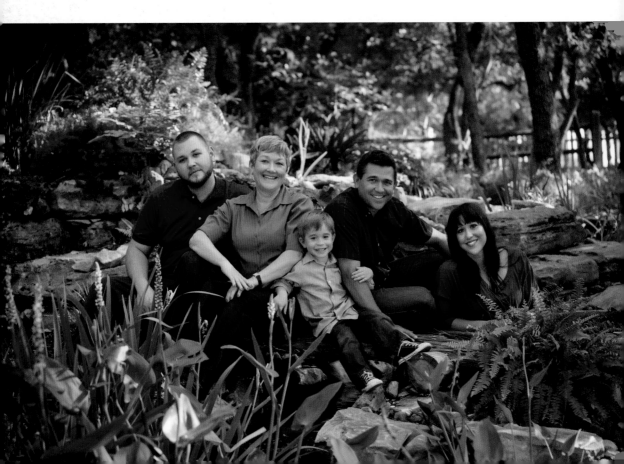

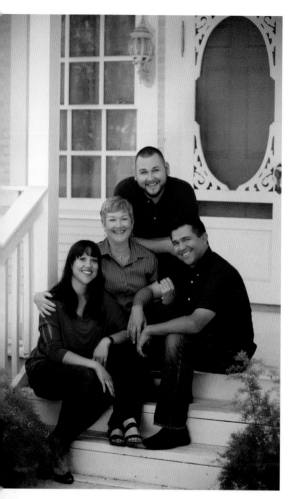

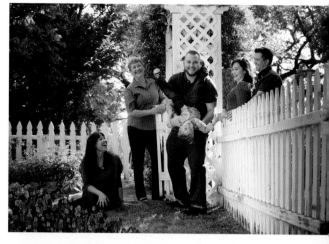

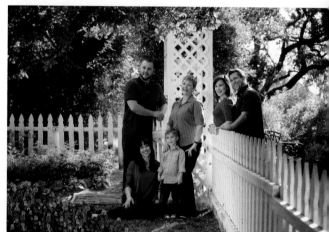

Exposure, Lighting, and Settings

The sun was our only light source; no off-camera flash was used. However, I did place a silver reflector approximately forty-five degrees to camera right to bounce light into their eyes. Their expressions were enticed by my assistant hitting me with a puppet, which families often think is hilarious.

The primary image was photographed with the 70–200mm lens on my Canon 5D Mark III set at 100mm. My exposure was f/5.6 at $\frac{1}{125}$ second and ISO 400.

33 | Bringing Baby Home

Finding the Perfect Location

This family wanted portraits made in their home with their ten-day old son. They had a very modern home, and as I looked around to see where I would photograph them, I found many little areas that were perfect to use as backdrops. The location in the primary image *(facing page)* is their entry way, with a table, a vase, and just a glimpse of the stairs. I placed the little boy on the table and used this as my base. I like the way the steps draw the viewer's eye into the family grouping. It is a contemporary home, and it defines who they are; it was a very simple home with a modern look without much clutter. The gray wall made for a great background, and the design of the staircase created a diagonal leading line.

Give Them a Variety of Secondary Images

Some of the other poses were more traditional with their faces clearly visible, yet still showing the surroundings of their home. They requested a black & white relationship portrait, which I normally photograph in my studio, but I arrived at their home prepared. I brought a black background and used the light from the door as my main light and the reflector to fill in the shadows.

Allow More Time for Newborns

Because we were working with a newborn, I allowed more time for feeding, changing, and

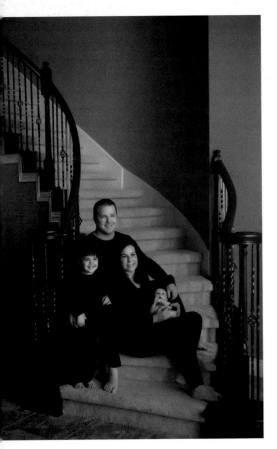

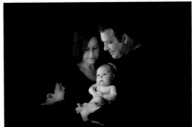

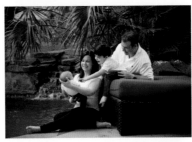

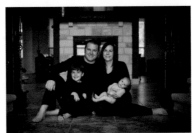

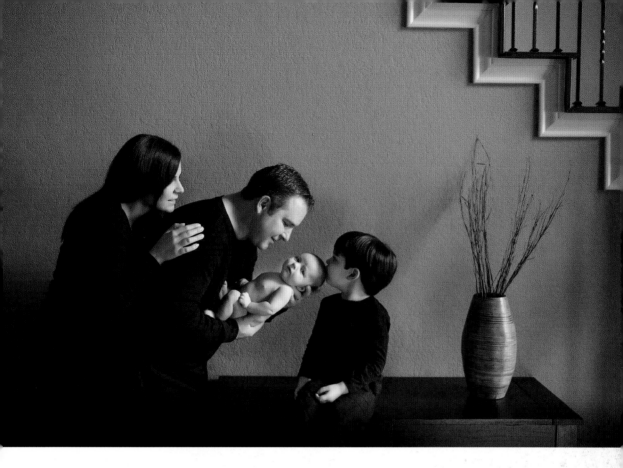

getting the baby to sleep. When babies are this young, we prefer to have them sleeping through the whole session. We usually allow for a three-hour session when we are photographing a newborn. In this instance, it gave the older sibling a break, and being in his own home, he was able to relax and play with his toys. If we were at the studio, Dad would have taken the older child outside and let him walk around while we worked with the baby alone.

Exposure, Lighting, and Settings

The primary image was photographed with the 28–70mm lens on my Canon 5D Mark III set at 28mm. My exposure was f/5 at $\frac{1}{125}$ second and ISO 800. This image was photographed with all natural light coming from the front door on camera right with a silver reflector forty-five degrees at camera left. No additional lighting was necessary.

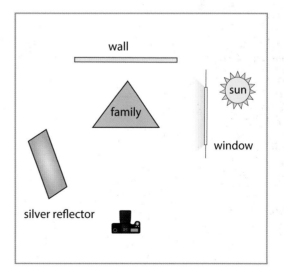

The Shy Child

This image *(below)* was taken very close to sunset on one of my Fall Family Portrait Days; this family got the best lighting of the day. This primary image of Mom, Dad, and their children sitting on the rocks by the water's edge was the same pose that they selected for their wall portrait. We had to work a little harder with their son because he was reserved and not as smiley as his big sister. However, by this point in the session, he had warmed up to us, and we were able to loosen him up and get him to smile.

Get to Know Your Subject

One nice thing about not having a super-fast session, which is a benefit of the last

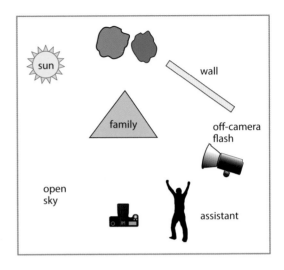

session of the day, is that we have the time to work with the kids (and sometimes their parents); it gives us the opportunity to get to know them more, and them us, and not have to rush through the session. In a quick

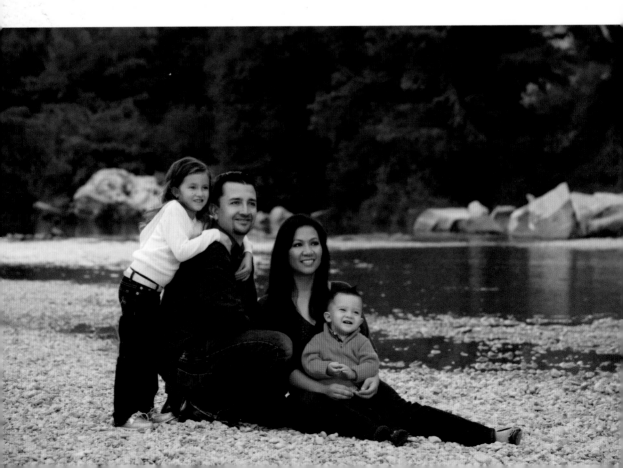

session, you do not have the luxury to have them relax and for all of us to get to know each other.

Family Day Events

Our busiest season runs from early October through December, and we struggle to fit in all of our family portrait clients during times that work for them. After all, there are only two weekend days a week, and everyone wants those days. This is why we instituted Family Day Events a number of years ago. We choose one location and photograph from sunrise to sunset, taking a break for lunch and bad overhead lighting. Therefore, instead of photographing one sunrise session and one sunset session on a Saturday, I am able to photograph six to eight families with one-hour sessions at the same location. This has been very popular for us and is sold out every year.

Exposure, Lighting, and Settings

The primary image was photographed with the 70–200mm lens on my Canon 5D Mark III set at 140mm. My exposure was f/7.1 at $\frac{1}{60}$ second and ISO 640. It was created with the late-day sun positioned at camera left, illuminating the family with an open sky. My off-camera flash, approximately forty-five degrees to camera right and next to my assistant, was used to bring light into their eyes.

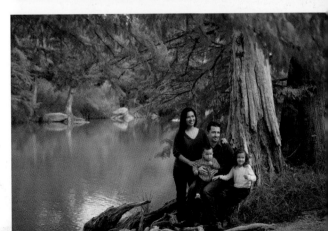

Family by the Fireplace

Photograph Your Client in Their Favorite Place

The outdoor fireplace *(below)* is one of this family's favorite spots; however, I also photographed them in other locations around their house. Their clothing choice of black and khaki was perfect and went well with this fireplace scene.

Find Out the Magic Word

This family was fun to photograph; I was able to elicit smiles from them pretty easily. When I photographed each of them individually, their sister helped me get the expressions I needed from her brothers by telling me the names of their girlfriends. Just saying their names evoked the expressions we needed.

Know the Needs of a Long Time Client

We have photographed this family numerous times, and they have often purchased wall portraits and albums. I photographed them by their hot tub (not shown) with the kids and their dog with a proper space in the middle so that it would work as a panorama for the album I knew that they would purchase.

When you have clients that keep coming back, you know what their buying habits are, and when you know that they are going to want another album for their collection, it makes it easy. You are not guessing about their order; you know

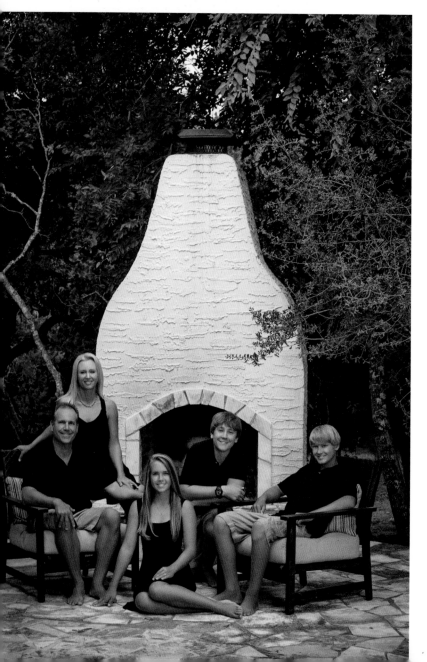

that they are going to purchase an album in addition to their wall portraits. Before I arrive, I am already thinking about what I need to photograph to complete the album, as well as how to compose their wall portrait.

We offer two different styles of albums, a magazine-style art book with multiple images per page and one with a single image per album page, which is what this client had purchased in the past. Knowing that the pages need to have complementary images, I am thinking of that when I am posing them for the album, and what photos would be the best for the panoramas.

The fun photo at the end of the session was the girl jumping into the pool, followed shortly thereafter by the rest of the family jumping in.

Exposure and Settings

The primary image was photographed with the 20–70mm lens on my Canon 5D Mark III set at 50mm. My exposure was f/8 at $\frac{1}{60}$ second and ISO 800.

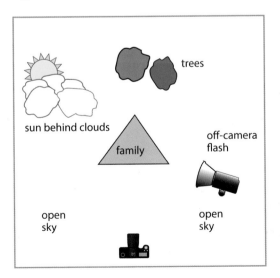

Repeat Clients Are the Best Clients

This premiere family began coming to me before they had children, and they were the first client to purchase one of my painted portraits. Because they believe in and trust in me, I have the opportunity every year to create a new portrait of their family or just the kids.

My Fall Family Portrait Special is all about family; therefore, they were sure to bring their dogs because the dogs are very much a part of their family. These pampered dogs are very easy going and easy to work with. I love interactive poses and this image (*below*) of them looking at the dogs and the one dog looking back at them while the other one sleeps was a favorite for everyone.

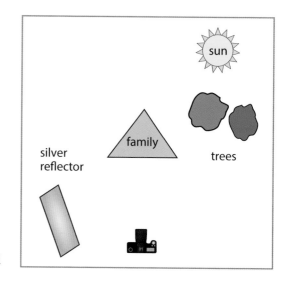

Early Morning Light

We had beautiful early morning light. The sun was behind the trees and the family on camera right. I used a silver reflector on

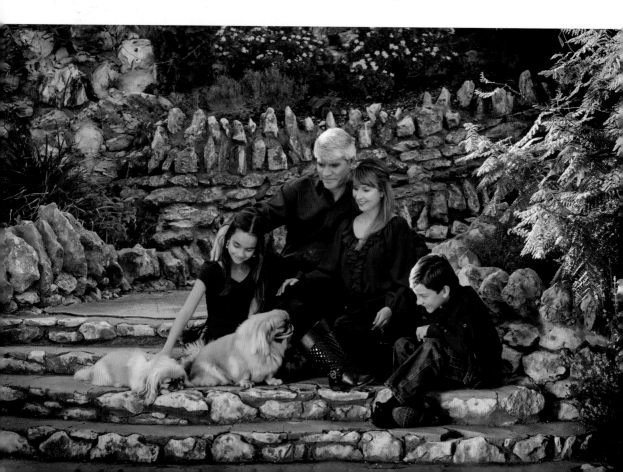

camera left to fill in the shadows and bounce light back into their eyes and faces. Mom picked the colors of the clothing because she wanted something with jewel tones. Clients who have come to me many times try to find colors that are a little different for their newer sessions. They have worn white, black, brown, and sometimes even prints; this time they wanted clothing in shades of purple and blue. This portrait with these tones looks great in their home.

Obtaining Permission or Permits

This location requires a permit for each session that I photograph, so on a day like this, when I will be photographing seven sessions, I needed to purchase seven permits that were dated and time stamped at $20 per session. This way, if I were to be questioned at any time during the day, I just had to produce the permit. However, when I photograph at the missions, the permit is for the day, not for each session; it is $100 whether I photograph one family or seven families.

Exposure and Settings

The primary image was photographed with the 70–200mm lens on my Canon 5D Mark III set at 150mm. My exposure was f/5 at $\frac{1}{125}$ second and ISO 320.

Photographing After Sunset

It was nearly dark by the time I made this image on the north shore of Oahu; the sun had already set, and the colors in the sky were getting more beautiful as we stood there. After photographing their son and daughter, I felt that the lighting was so amazing that I had the parents stand by the edge of the beach so that I could create this family portrait *(below)*. This image has such a serene feeling and I felt that it would be a beautiful wall portrait.

We usually start about two hours before sunset so that we have plenty of light. We photograph every combination during this time. The day had beautiful lighting, per-fect clouds and enough sun to give direction to the light but not be too harsh.

Painted Portrait

The painted portrait is what I call my Signature Series Portrait; it is the highest end

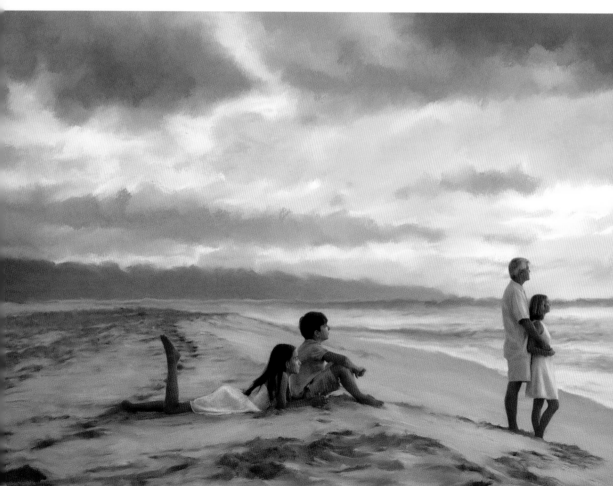

product that we offer. When a client requests a painted portrait, the first thing I do is suggest that they purchase a portrait, and I will make a preview of what it will look like painted. Usually, when someone sees their image painted, they want it, and we finish it once they have given us the okay. We go into finer detail and then have it printed; it is a multi-step process. It is printed on canvas, and then it is enhanced with oils and gels on top of that and finished with brush strokes. The finished product looks very painterly, and it al-

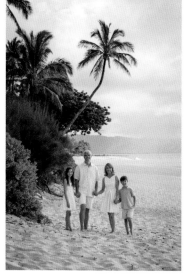

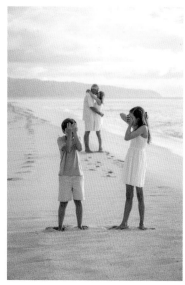

ways stops the viewer in their tracks. It is the product that once seen, people cannot stop talking about it. It is a conversation piece and a work of art for their wall.

Exposure, Lighting, and Settings

The primary image was photographed with the 70–200mm lens on my Canon 5D Mark III set at 85mm. My exposure was f/4.5 at $\frac{1}{100}$ second and ISO 2000. I used an off-camera flash in the photo where they are standing at the edge of the beach and their daughter is pointing out to the ocean, but all the rest of the images were created with just natural light and no reflector.

A Different Perspective

I photographed this family on the gnarly roots of the trees by the Guadalupe River. By changing my camera angle and lying flat on the ground, I gave this image a different look than an earlier portrait photographed at the same location. This family has grown up with me, and every year we have to search for someplace different to find a new location for their portrait.

In addition to photographing the family on top of the gnarly roots, we moved to an open area with a rock cliff, using the fall colors in the trees and pretty yellow flowers as a backdrop. The younger daughter added color to the image by holding a small bouquet of yellow wildflowers.

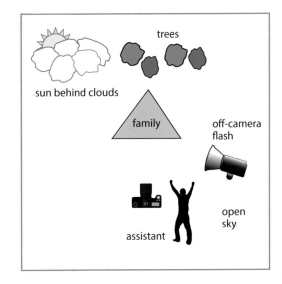

Entertaining the Baby

The baby of the family is clapping his hands, which means that we were probably singing at the time to keep him occupied

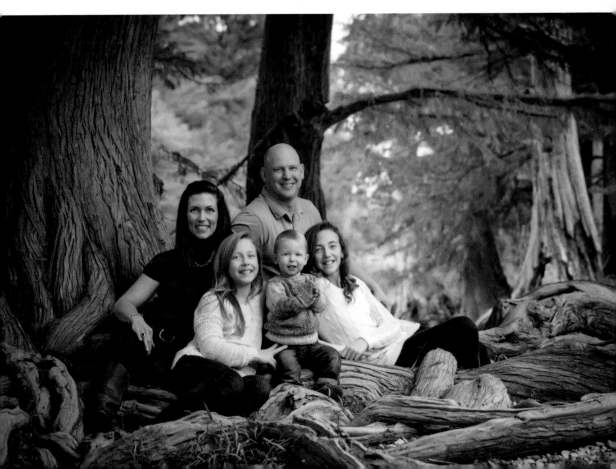

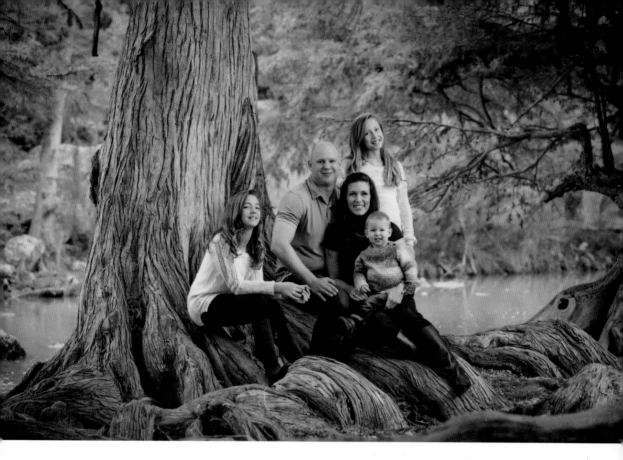

and paying attention to us. A few of the songs that entertain children of this age are "Itsy Bitsy Spider" and "If You're Happy and You Know It, Clap Your Hands." It is important that my assistant be able to carry a tune; we want to entertain our clients, not scare them with off-key voices. Because Trey has a degree in vocal performance, I usually let him do the singing. Trey was my assistant for this session; he was standing next to me on camera right, getting the attention of the baby as well as the rest of the family.

Exposure, Lighting, and Settings

The primary image was photographed with the 70–200mm lens on my Canon 5D Mark III set at 95mm. My exposure was f/5 at $\frac{1}{125}$ second and ISO 400. The sun was obscured by clouds and positioned behind the family somewhat on camera left. I used an off-camera flash on this overcast day, approximately forty-five degrees to camera right, to add a little light into their eyes.

Popular Location

This venue has a number of little shops in an old time setting with barns and old buildings. There are many wonderful places to photograph. The big red barn is a great draw and many clients request it. This family is one of my premiere clients that come to me every year. Mom has arranged for us to photograph them in every location that I use, so we now have to start looking outside the box.

Find a Motif That Fits Your Client's Personality

The barn motif fits their personality because they are a country-western family that likes to hunt and fish. Mom purchases albums every year, so I knew how I had to compose my images for variety. I had to be sure that I gave her a wide range of distinct poses and locations so that there was very little, if any, repetition.

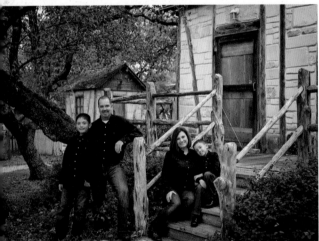

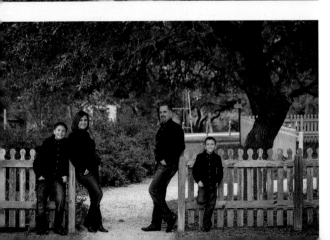

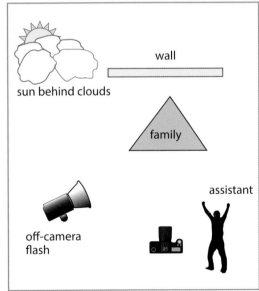

Perspective

This image *(right)* is a perfect example of showing perspective. I do not want them filling the frame; I want the viewer to see that they are standing in front of a large red barn. After I began photographing in this manner, I had to showcase the portraits on my wall so that my clients could see that it is okay to show the background. It sometimes takes a while for clients to grasp the concept that what I create is more of an artistic type of portrait, instead of the cookie cutter image. I want my portraits to have visual interest and be more of an art piece.

Be Prepared for All Situations

I always have my flash and reflector in my car, just in case I need it. Light changes throughout the day, and while I might not need the flash when we first arrive on location, sometimes it is necessary to bring it out and use it before the session is over if the clouds roll in and block the sun. I am ready to use my off-camera flash on a cloudy day and my reflector on a sunny day.

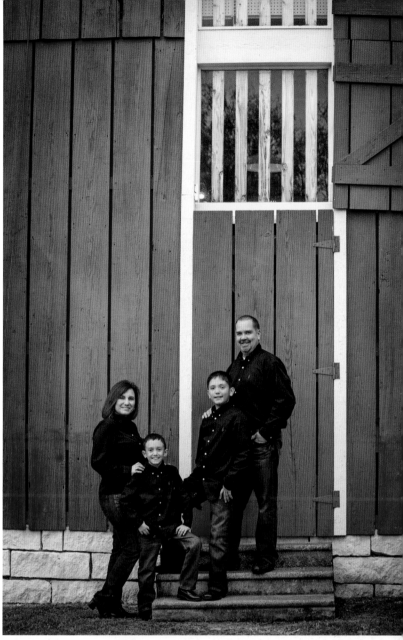

Exposure and Settings

The primary image was photographed with the 70–200mm lens on my Canon 5D Mark III set at 70mm. My exposure was f/5 at $\frac{1}{125}$ second and ISO 640. I placed an off-camera flash at camera left for some directional light because it was a gray, overcast day.

Multi-Purpose Building

About seven years ago, we decided to add a building for storage of off-season props, and negatives. We built this building for that purpose, but we also wanted to have porches on it for another place to pose our clients. We built it with a white Victorian porch; it has definitely paid for itself because I use it all the time. It is a great location for families, kids, and high school seniors. One of the great things about being on a porch is that I always have nice directional lighting. For this image, I have a silver reflector that is set up on camera left at the bottom of the steps that throws back just a little kick of light. I did not use any off-camera flash, just the reflector with the

natural light. My assistant was slightly behind me on camera left to gain the attention of the family, probably doing something

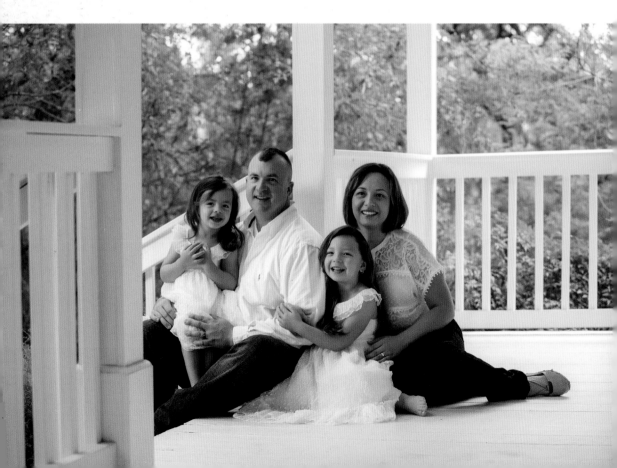

funny directed toward me right outside my peripheral vision. The two little girls were totally into the session; they were very engaged.

Utilizing the Property

The other images in this series were also photographed on our 2.5 acre studio property. We changed locations a few times to be sure that they had enough variety in case they wanted an album, as well as to give them many options for wall portraits and gift photographs.

Leave Them Wanting More

In order for my clients to keep coming back for more, I have to be sure not to give them every option when they come to the studio. I want their next session at the studio to be photographed on another set I can offer. We have been in this location for twenty years and have created a portrait garden that has gorgeous settings; however, each year we try to work on an area to improve it or add a set or new option either inside or outside. I continue to get ideas from seminars, antique stores, and fashion magazines so that I remain fresh and current.

Exposure and Settings

The primary image was photographed with the 70–200mm lens on my Canon 5D Mark III set at 90mm. My exposure was f/5 at $\frac{1}{125}$ second and ISO 640.

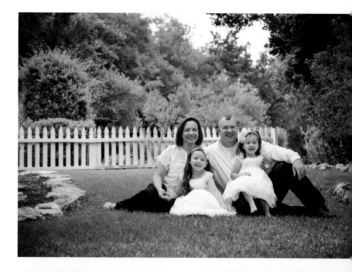

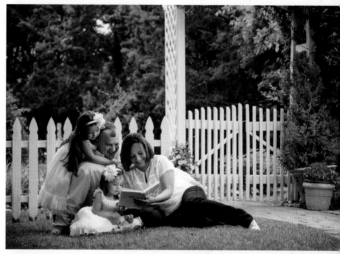

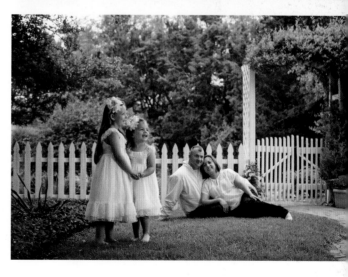

Color Harmony

This family wanted their newest session to be at the Mission San Jose. Mom worked very hard coordinating the outfits with the brown shirts and blouses with the jeans and cowboy boots. I love the color harmony and that their skin tone matches the rock and the brown in their shirts match the walls; it all came together and really worked well.

Time Constraints

The mission is only open until 5:00PM, and sometimes that is just too early to finish photographing; in this case, it was earlier than I would have preferred. We started at 3:30PM and we had to work with backlighting. The primary image *(below)* was one of the first photographs.

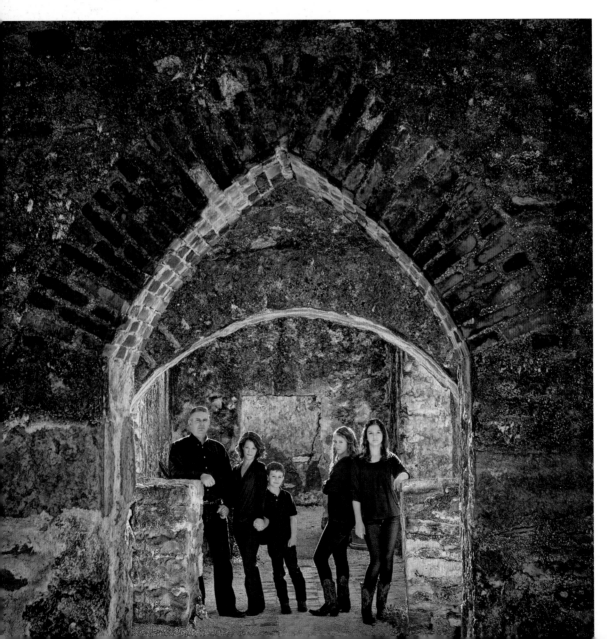

Indirect Lighting

It was wonderful that I did not need any other lighting for this image because the sun was hitting the left side of the wall that I was photographing through and bouncing the light back into them. It was a perfect scenario to be able to get great light on their faces, and it balanced out with the nice hair light.

Architecture and Posing

Dad was leaning on a half wall, about ten feet from the wall that I was photographing through. There are many design features at this location; there was an arched wall with the pointed apex and the bricks above it, which was right in front of me. Next was an arch that is rounded with the two columns and behind this was a vaulted doorway.

Creating Dimension

One of the things I love to do with architecture or natural architecture is to have it create dimension in my images with a foreground, middle ground, and background. This image is a great example. The foreground is the arch in front of me, the middle ground is the family, and the background is the vaulted doorway behind them. This adds depth to the image and makes it a little more realistic and not so

flat. This was the primary image in her wall grouping, of which there were seven that she purchased for her wall collection.

Exposure and Settings

The primary image was photographed with the 24–70mm lens on my Canon 5D Mark III set at 40mm. My exposure was f/8 at $\frac{1}{125}$ second and ISO 400.

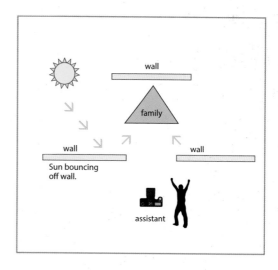

Perfect Size Group

This is the perfect sized family and age group that I like to photograph on my property. Any larger groups or older children make my pond look small, so I try to keep it with just younger kids, and preferably, no more than four people, especially by our pond. It is also suitable for individuals; I photograph a lot of high school seniors in this area.

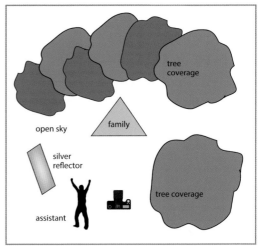

Early Morning Session

I photographed this family in the spring at approximately 8:00AM. There are a lot of trees at this location, which provided the shade, but they also added to the chilliness

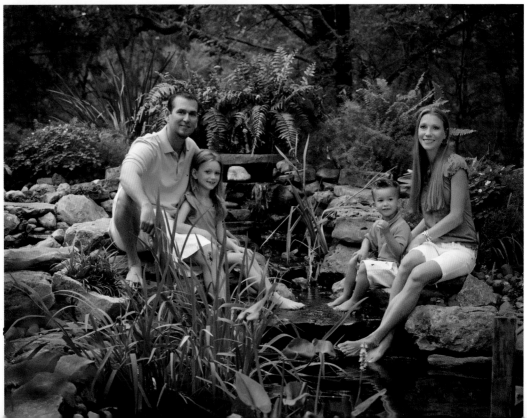

of the morning. The early morning sun was behind clouds, so I used a silver reflector approximately forty-five degrees on camera left to bounce light back into their eyes. The little boy was squirmy, so I had him sit on Dad's shoulders to keep him from running off. The daughter just happened to lean and lie on Mom's leg at an opportune time. That was not something that was planned or posed, it just happened. This was their favorite image and was selected for their wall portrait.

Getting the Parents to Listen

The parents are looking directly at me, but the kids are looking at my assistant who was standing next to me on camera left. This can be an issue sometimes because the parents think that they should always be looking at the camera, even though I instruct them to look at my assistant. I try to keep an eye on this to be sure that everyone is looking in the same direction. The difficulty comes when I assume that the parents will follow my instructions, and I am watching the kids, making sure that I have good expressions, and they are looking where I want them to look. This is a good example of what can happen, not that this is bad. It is just not preferred.

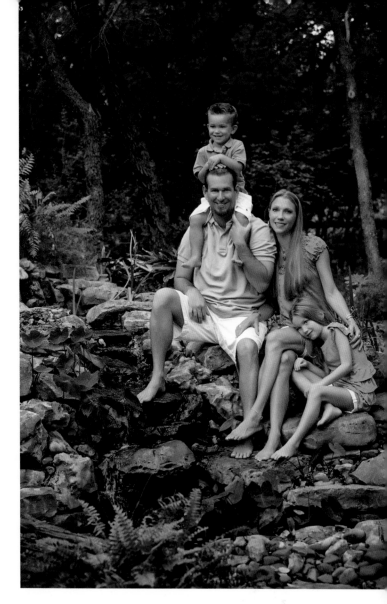

Exposure and Settings

The primary image was photographed with the 70–200mm lens on my Canon 5D Mark III set at 80mm. My exposure was f/5.6 at $\frac{1}{125}$ second and ISO 400.

43 | **Country Chic**

Long-Time Client in an Old Town

I have been photographing these girls since they were babies, and the youngest one is about to be a senior in high school. We create a family portrait for them every five years to add to their collection. For this session, we went to Gruene, which is a little town that the Guadalupe River runs through. It is a quaint, antiquing town with the look of the late 1800s. Because the old time look has been preserved, it has a num-

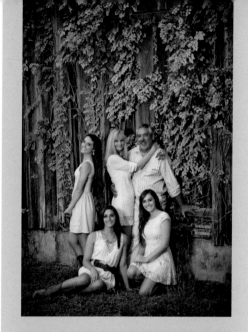

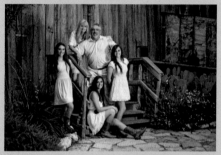

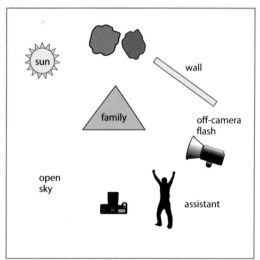

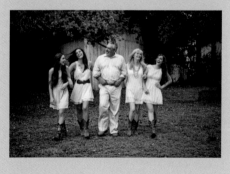

ber of old barns and cute areas, as well as the river, which make for a variety of great backdrops for my portraits.

White and Turquoise

This family wanted something country chic because the girls love these short skirts and their cowboy boots. They obsessed over the colors for a while, but they decided to wear light tones, white and turquoise dresses with turquoise accents. Dad just had to wear khaki slacks with a light striped shirt.

It Is Fun to Photograph Fun People

These young women are naturals at posing and they know how to do it. They are always posing; they are involved in sports and sororities and take selfies all of the time, and they grew up in front of my camera. The three sisters are really a lot of fun—a little obsessed with their hair but they like to ham it up. There is nothing fake going on with them. They just enjoy having a good old time; they were a lot of fun to photograph.

They are at one of my favorite ages to photograph; we are pretty much past the attitude and tension stage. They honestly

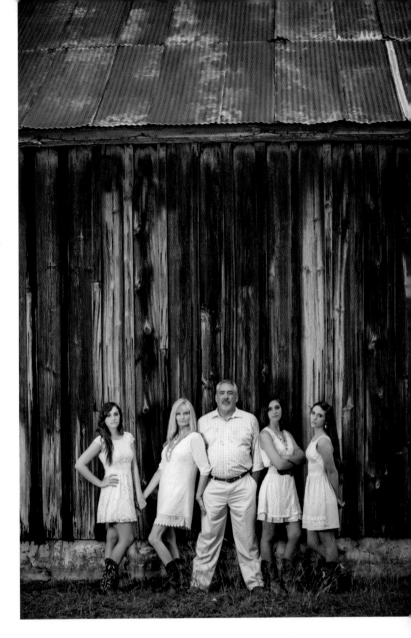

enjoy each other, and it really shows in these photographs.

Exposure and Settings

The primary image was photographed with the 70–200mm lens on my Canon 5D Mark III set at 70mm. My exposure was f/5 at $\frac{1}{125}$ second and ISO 320.

Sands of Time

A Referral from Another Photographer

This family came to me by way of a referral from a photographer who is located in another part of Texas. My photographer friend knew that I was going to be at the

beach photographing family portraits, and she knew that this family was going to be there at the same time. She made the connection between her client and me, which was very nice. I love it when other photographers refer clients to me or ask me to photograph their families. It is a very good feeling to know that your colleagues trust you that much.

Getting to Know the Subject

I had never met this family before the day that I photographed them, although Mom and I spoke on the telephone. We went over the clothing suggestions, and I got some information about the five of them. When the session first started, I was getting

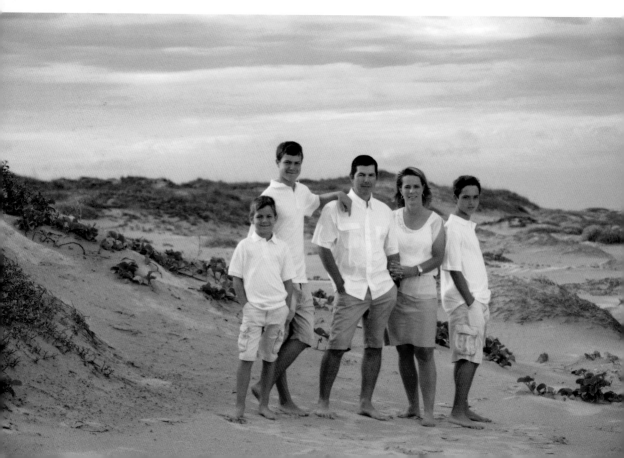

cheesy grins on some of the boys, but as the session progressed, they began to warm up, and I was able to capture natural expressions. A lot of people still have the idea that a portrait session is going to be stuffy, even at the beach. I try to make it more relaxed and more fun, and usually by the time we are mid-way through the session, they are accustomed to the routine of my photo session.

We were fortunate to have perfect weather and a beautiful day; Mom and Dad loved the photographs. The primary image (*facing page*) was their selection for their main wall portrait, but they also have a wall collection of some of the other photographs to complement the primary photograph.

Exposure, Lighting, and Settings

The sun was behind the family on camera left, and there was a lot of open sky. However, because it was close to sunset, I used an off-camera flash placed at camera right for some directional light on their faces. South Padre Island is always a great place to create family portraits, especially at sunrise or sunset.

The primary image was photographed with the 70–200mm lens on my Canon 5D Mark III set at 80mm. My exposure was f/8 at $\frac{1}{125}$ second and ISO 200.

Relationship Portraits

I love generation portraits, and this one consisted of the grandparents, their daughter and her husband, and their granddaughter. I borrowed the term "relationship portrait" from my friend, Tim Walden. These portraits are really focused on the people; they are not about the background or the setting, but more about the interactive relationship among the individuals in the portrait.

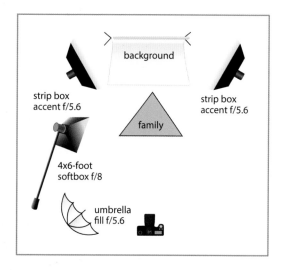

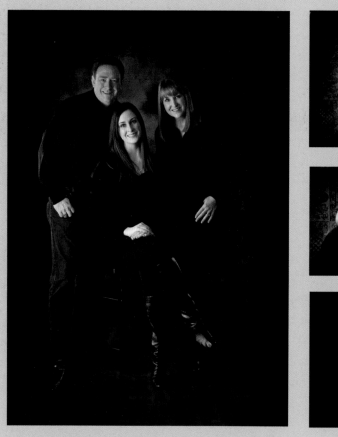

Photograph in Color, Convert to Black & White

This family wanted portraits in black & white and color; I photographed everything in color and during the viewing process, I showed them what their portraits looked like in black & white. They were very happy with what I had done and purchased a number of portraits in both black & white and color. While the color makes for beautiful portraits, there is something about black & white that adds to the relationship feeling.

Different Background for Different Looks

I used two backgrounds for this family. The images with the Denny's old tin tile appearance went well with the black & white. This background is muted and khaki colored and a little more contemporary, and whereas it works in color and black & white, I preferred it for just the black & white portraits. My other background for this family was my more traditional tapestry background from David Maheu. The grandparents preferred the more traditional background while their daughter and her husband's preference was the contemporary look.

I gave them enough variety in posing and backgrounds and the choice of color or black & white for them to select portraits, create wall collections or an album or two, so that everyone was happy.

Exposure and Settings

The primary image was photographed with the 70–200mm lens on my Canon 5D Mark III set at 80mm. My exposure was f/8 at $\frac{1}{125}$ second and ISO 125.

46 | Family Tree

Going the Extra Mile with a New Client

The gnarly roots of the trees on the shores of the Guadalupe River are a lovely place to photograph, but an uncomfortable place to sit. This family was part of my Fall Family Day Special in which I spend only one hour with each client, yet I am still able to offer them a wide variety of poses. This was the first time this family had taken advantage of my services. New clients are always hard to get, so I appreciate and always try to go my usual extra mile with each client, especially someone recent. You have to try harder with new clients to be sure they become repeat clients, which is what happened with this family.

Coordinating Colors

This was a good looking family that did not have to work at it; they were just that good

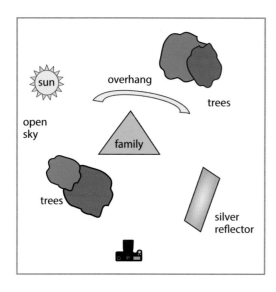

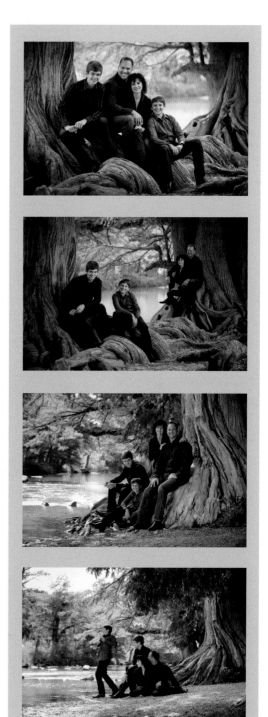

looking. Dad sometimes had a little bit of a cheesy smile, but they did well as a family. Mom did a great job coordinating the colors in the clothing. The fabric of the older son's shirt had a pattern, but the pattern was subtle so it worked with the tones of everyone else's clothing.

Creating Levels and Depth

By using the roots of the trees, I was able to place everyone on different levels, and I was also able to use the concept of foreground, middle ground, and background. The tree on the left is slightly out of focus as is the foreground, giving depth to the image. The middle ground is the family and the trees on the right serve as the background; this adds dimension to the portrait.

Exposure and Settings

The primary image was photographed with the 70–200mm lens on my Canon 5D Mark III set at 70mm. My exposure was f/4 at $\frac{1}{200}$ second and ISO 320.

Nine Kids and Counting

Reconnecting with an Old Client

Mom, Dad and their nine children were photographed during a destination portrait session on the beach in Destin, Florida. Their oldest child is getting ready to leave for college and the youngest is the baby on Dad's lap. I began photographing this family when they only had five children, and then they moved from Texas to Georgia; I did not see them for a number of years after they moved. Mom called me, knowing that we travel to Florida to create portraits on the beach. She wanted to know when our next trip was scheduled; they wanted me to photograph them while they were on vacation. Destin is a favorite location spot for families, especially in the South. Their beaches have simple white sand and crystal clear blue water on Florida's panhandle.

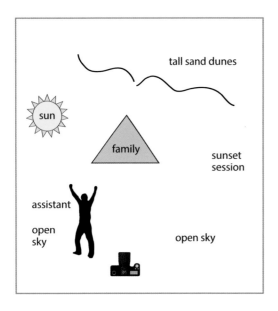

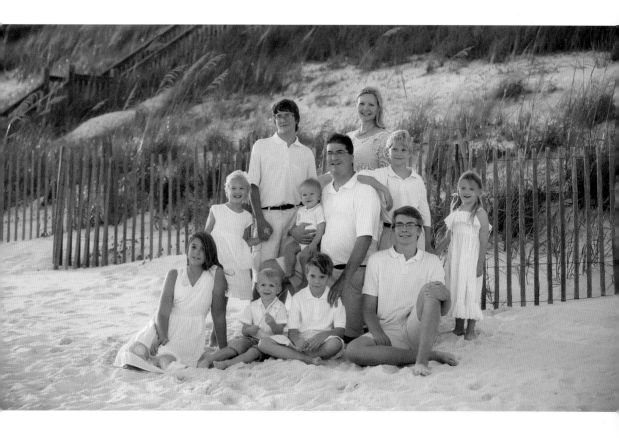

Cooperation

There is something about raising a family with a lot of children that the parents know how to make sure that the kids behave, and these kids were awesome. Everybody was happy; they listened and did as they were instructed, and they were a fun group. I was able to get a variety of family portraits, each of them individually, all the kids together, and Mom and Dad in some romantic poses (which of course, after nine kids, they did nicely). Trey was fantastic working with the family. He kept them laughing and worked with them while I captured their great expressions. To be honest, he worked with ease with this family because they were so cooperative. However, he stretched out each act for five minutes or more, keeping them entertained while I photographed them. Watching Trey evoke expressions is like watching a polished comedy act. He always plays to the youngest, with the hope and expectation that the others will smile and laugh as well.

Exposure and Settings

The primary image was photographed with the 70–200mm lens on my Canon 5D Mark III set at 100mm. My exposure was f/5.6 at $\frac{1}{125}$ second and ISO 320.

48 | Shades of Pink

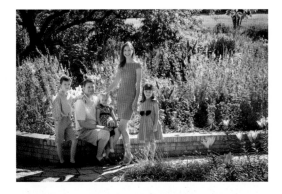

Pastel Colors and Casual Attire

Mom likes pastel colors but selected a vibrant pink dress for herself. Then she coordinated everyone else's clothes around it with colors and patterns to match. She kept it casual with comfortable shoes for everyone and khaki shorts for her husband and son. Even though the baby's dress had a pattern, it is not distracting. The range of pink tones work well together in this photograph.

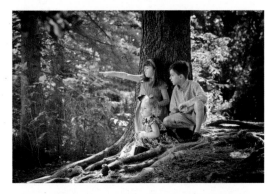

Challenging Age Groups

This was one of those sessions that can be a little bit challenging because of the ages of the children. The son was seven and the girls were four and two, which makes for a fun age group with which to work. As Trey had mentioned in an earlier section, what a two-year-old girl responds to is completely different than what a seven-year-old boy

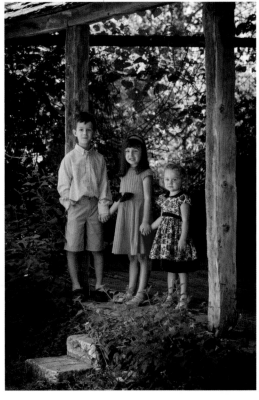

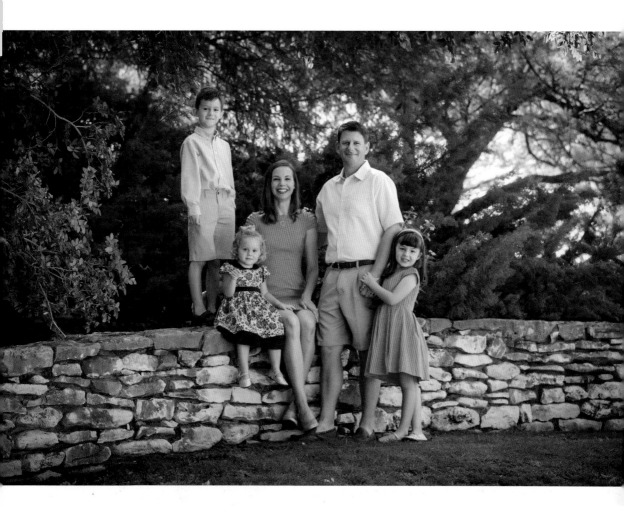

responds to. The baby was shy and did not want to smile; this was probably her best expression all day, but it is important to note that it only takes one good exposure for the family to love the photos.

Posing in a Perfect World

If it were a perfect world, I would have crossed the little girl's ankles, which my assistant and I did numerous times, but she continually bounced them wide open. It was a situation that I could not win, so my feeling was to go for the expression and not worry too much about her legs. I knew

that if I fussed with her feet too much, I was going to have a very unhappy child; sometimes you have to know when to stop working on the pose and when to go for the expression. In the end, it was all about creating a nice saleable wall portrait that the parents would love.

Exposure and Settings

The primary image was photographed with the 70–200mm lens on my Canon 5D Mark III set at 170mm. My exposure was f/5 at $\frac{1}{125}$ second and ISO 320.

49 | The Bond of Family

Black & White Portraits

When this family first contacted me for a portrait session, they requested a black & white portrait for their wall. My relationship portraits are just that, showing the relationships within the family. Most images are cropped tightly. I sometimes use the parent as a *prop* by not even showing his or her face. These black & white portraits are usually created without big smiles and are timeless; they are a display of fine art photography. I also did a number of breakdown poses of the kids together, the kids individually, Mom and Dad without the kids, Mom with each son, Mom with both boys, Dad with each son, and Dad with both boys. This makes for a great collection, either for an album or for a wall grouping. The simplicity of the images also makes for

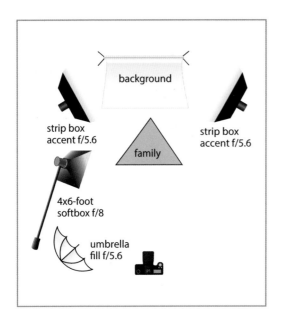

a great grouping of our Signature Series Floating Art Pieces. These are archival, fine art float-mounted images printed on fine art paper with white mats and a simple frame. Our clients love these images presented in this museum style.

Creating Timeless Portraits

Mom prefers the simple look, which worked very well for her wall décor in their contemporary home. Their clothing is classic and timeless; the solid black was perfect for this session and what she wanted. This portrait is ageless; I could have made this image twenty years ago, or I could have made it yesterday. The viewer would never know. This is what I love about these classic portraits; they are

not dated with the trendy styles of today, whenever today is. I have been creating these black & white portraits for over fifteen years, and my clients never tire of them. Some come back to have a new session to add to their collection. Some love it so much that they have done it year after year. Either way, adding this style into my repertoire has been a great addition and is the perfect option during bad weather months because they are usually done inside.

Exposure, Lighting, and Settings

The primary image was photographed with the 70–200mm lens on my Canon 5D Mark III set at 165mm. My exposure was f/9 at $\frac{1}{125}$ second and ISO 125.

Photographing in a Park

I enjoy photographing families in their neighborhood or on their property. This family lives in the country, and they wanted

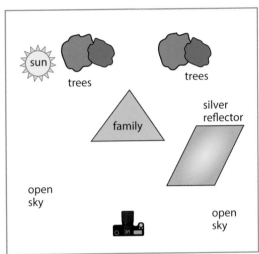

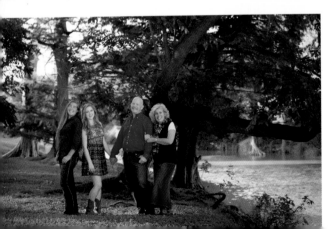

to be photographed in this park near their home, which was about an hour's drive northwest of San Antonio. Because this family lives in the area, and the park is considered part of their community, we were able to use the park without paying a fee.

Even though it was a sunny day, I was able to place them in shade that came from the cliff that was behind them, as well as the trees and bushes surrounding them. I used a silver reflector on camera right to help bounce some light back into their faces.

Posing the Family

In most cases, I have each person bend the leg that is closest to the camera. It gives the body a nice "sway" and gives the pose a more natural feel. It also can make the subject appear slimmer than they really are. If mom loves the way she looks, she will love

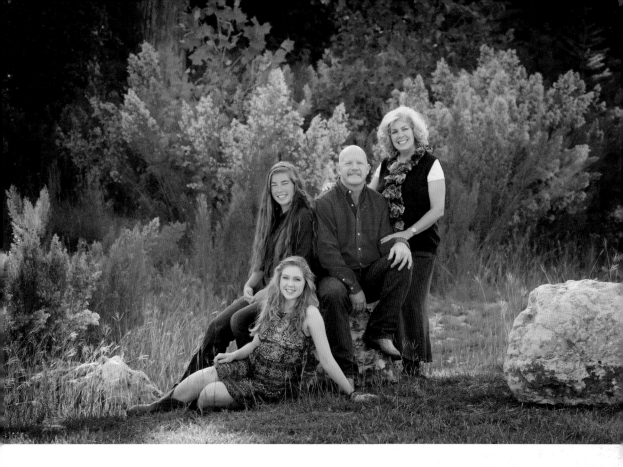

the portraits. In this book ninety-nine per-cent of the portraits are completely posed

Non-Seasonal Seasonal Portraits

This session was created in the fall, and they wanted something special for their Christmas card. They wanted to change their clothes and had me photograph them around their red pickup truck specifically for their Christmas card. When I am photographing a family session around a holiday, I do not want the portraits to be seasonal. If they are just interested in Christmas cards, they may put off, perhaps forever, the beautiful portrait for their wall or an album. Even if that is what they specifically request, I will still have

them dress in non-seasonal clothing and photograph them so that the poses do not connote a holiday, and save the seasonal portraits for the end of the session.

Exposure, Lighting, and Settings

The primary image was photographed with the 70–200mm lens on my Canon 5D Mark III set at 170mm. My exposure was f/5.6 at $\frac{1}{125}$ second and ISO 320.

Sunrise on the Beach

I created this series of portraits with Mom, Dad, and their three beautiful children at sunrise on the beach with a lot of open sky and without an off-camera flash or reflector. They are one of my regular clients and traveled to Florida for this destination portrait.

Overcoming Energetic Children

The kids were adorable, but difficult to work with, primarily because of their age; they were very energetic, which made the session challenging. It was early morning, and all they wanted to do was run, dig in the sand, and anything else except stand still for a photograph. Trey pulled out all the stops to entertain the kids and get them to focus on him. We have photographed this family so often that the kids call us Aunt Elizabeth and Uncle Trey, so they think that they can run the whole show. The downside of having kids come to us very often is that they get too comfortable with us. Sometimes we feel we have more authority if they are not completely at ease. The end result for this session was that the kids did very well due to Trey's diligence. I never obsess over posing; I just want them

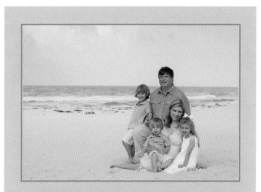

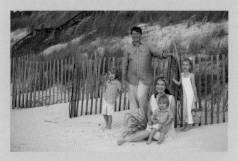

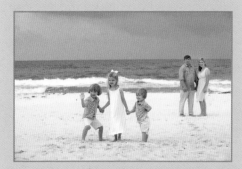

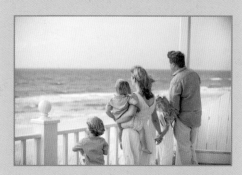

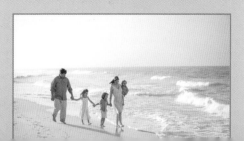

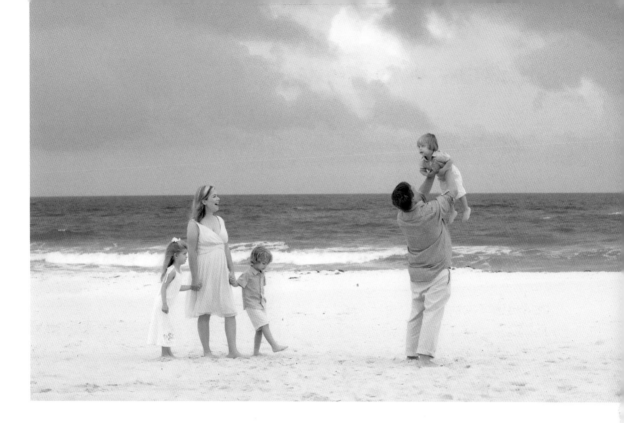

each looking in the same direction with a good expression.

Creating a Wall Collection

The primary image *(above)* was an interactive pose, which looked great and worked well for this family. Dad lifted the littlest one in the air, while the other two children ignored us; all they wanted to do was kick the sand. We fought that a little bit, but decided to let them do it because it was cute. I intentionally left the middle open so that they could create a diptych with this image, as that was what Mom wanted for her wall.

Exposure, Lighting, and Settings

The primary image was photographed with the 70–200mm lens on my Canon 5D Mark III set at 120mm. My exposure was f/5.6 at $\frac{1}{125}$ second and ISO 640. There was a storm brewing around the time of this session. So we also had the element of the stormy weather, the churning of the water, and the wind kicking up. The sun came out, but it was a little touch-and-go for a while.

Large Groups, Limited Space

I generally try to steer people away from large family groups on my property because the sets are all designed for individuals or smaller groups. I like space in my images, and large groups limit what I can do. I would have preferred more space with this group, but you work with what you have in the space that you have.

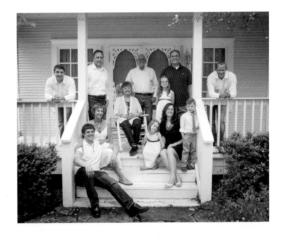

Pre-Portrait Consultation

When I have a pre-portrait consultation, I try to have a representative from each family within the larger family group present so that the color coordination is clear to everyone. In this instance, most of the family was dressed casually in white or light shirts with jeans, except for one man who is wearing a burgundy shirt, his wife is wearing a deep purple dress, and their young son is wearing a checked tie; the boy and his dad are wearing khaki slacks. I try to persuade them to

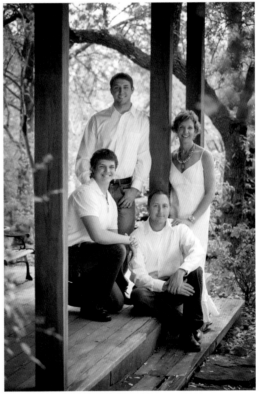

wear one or two colors; if they wish to have a third color in the portrait, burgundy in this instance, that the third color should be

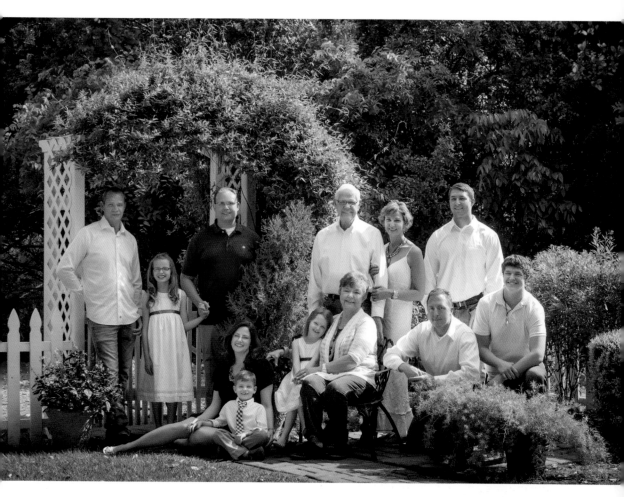

worn by more than one person, or that one person will stand out. I would have preferred it if the burgundy had been sprinkled more throughout, or if they had worn a tone that was not as dark, because everyone else is in light colors. The end result was that they were not bothered by the space issue, and they were happy with their color choices, making this a successful portrait session.

Exposure, Lighting, and Settings

The primary image was photographed with the 70–200mm lens on my Canon 5D Mark III set at 80mm. My exposure was f/8 at $\frac{1}{125}$ second and ISO 320. I used an off-camera flash on camera left because we were working early in the afternoon and I needed the extra light to fill in their faces to balance out the sunlight hitting them on their backs/sides. I would have preferred photographing them later in the afternoon, but this time frame worked best for them. Sometimes you have to work in conditions that may be less than ideal. Having the tools to make the session successful, such as an off-camera flash and reflectors, is imperative.

Family Made of Love

Creating a Flattering Portrait

This was a very loving family, and the girls were very sweet. It was important to me to diminish Mom's size because Mom is usually the one that has to be happy when decisions to purchase are being made. Mom was really not very big, but she was concerned about looking heavy, and in order to not

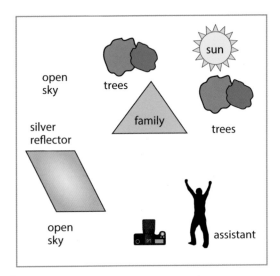

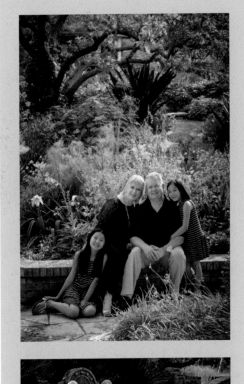

overpower her daughters, I needed to hide a portion of her body. I always take Mom's feelings about her size to heart, because as a woman, I can empathize with her. Having her pose sitting on the wall with her younger daughter standing in front of her, hiding half of her body, helped to diminish her size. I continued this thought with the other photographs in this series by turning her or having her partially blocked.

Mastering the Individual Poses

You will notice throughout my family images that poses of individuals are repeated. There is generally one sitting feminine pose and one standing feminine pose and the same for men. There may be variations of each pose, but generally, learning these poses is very simple. Here, Mom is in the seated feminine pose and the daughter on

the left is displaying the standing feminine pose (front leg bent). Dad has all his weight on the back leg with the front leg bent, which is the perfect standing masculine pose. It is important to master these poses so that you can show the family what you want them to do quickly and easily.

We created these portraits on one of our Spring Family Days at the San Antonio Botanical Gardens, in which, we have one hour to photograph each family. There were a lot of pretty flowers that we could use as a backdrop in some of the photos, but we also had some strong direct sunlight hitting their heads. The sun was behind them and the trees, high in the sky on camera right with a lot of open sky. My silver reflector was approximately forty-five degrees to camera left, bouncing light back into their eyes.

Exposure, Lighting, and Settings

The primary image was photographed with the 70–200mm lens on my Canon 5D Mark III set at 95mm. My exposure was f/11 at $\frac{1}{125}$ second and ISO 400.

Posing Amongst the Cow Patties

This family wanted to use their farm and old barns as a background; they also wanted me to bring my studio couch, something I thought was a bit incongruous. It was an interesting concept to have the couch in a pasture with cows in the background and cow patties all around, with the family posing around the couch. I cleared the cow patties away from the area where the young man was sitting on the ground. There was a lady keeping the cows away, but eventually momma cow and her calves wandered into the area where we were photographing; I loved how it all came together and worked perfectly. The family's interaction also helped to create interest in this photograph with mother and son looking at each other and father and daughter in the back looking at each other.

Early Morning Sunlight

The session began a little before sunrise, and this image *(facing page)* was photographed shortly after sunrise with the sun rising in the open sky, using only a silver reflector on camera left to bounce light back into their faces. My choice of reflector is the Fuzzy-Flector, created by Fuzzy Duenkel. This four-sided 4x4-foot reflector stands alone and works in most lighting conditions. Once I made this reflector, using Fuzzy's plans, I have never used another one. It is that good! Here is the website to order the plans

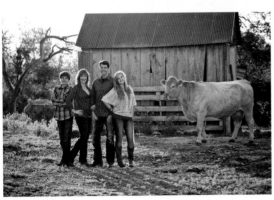

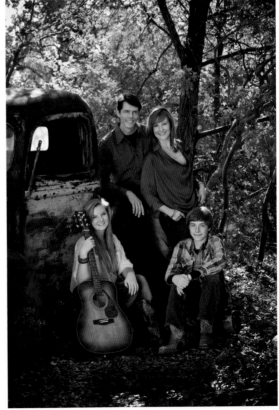

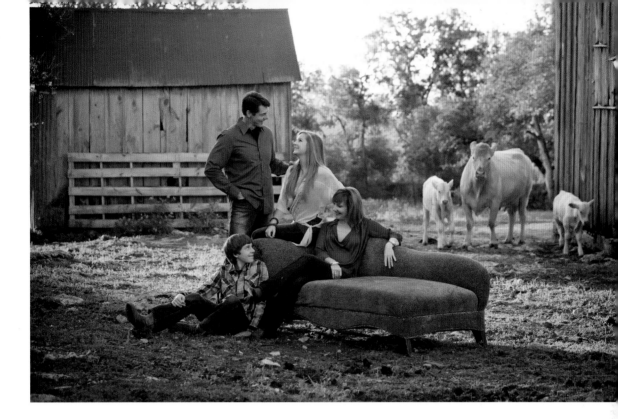

to build one for yourself: www.duenkel.com (order the Fuzzy Logic PDF).

Complementary Clothing

The clients' choice of clothing was excellent, complementing Mom's hair, the barn, and the cow. Clothing is as important for location portraits as much as it is for studio portraits. We want to be sure that the clothing is complementary and does not overpower the subjects.

After we finished the first part of the session at this location, we traveled to two other spots. We finished the session on my studio property, using the cabin as the background and Mom in the rocking chair, and finally, the family sitting and leaning against our old, weather-beaten truck in a wooded area.

Exposure, Lighting, and Settings

The primary image was photographed with the 70–200mm lens on my Canon 5D Mark III set at 80mm. My exposure was f/4.5 at $^1/_{200}$ second and ISO 400.

Expectant Family

Creating Drama

The husband's mother used to work for a photographer. She has said how much she loves my work and the drama that I create in my images, so I wanted to make sure that I created drama in the lighting and posing in these maternity images. When photographing a pregnant belly, I prefer to use a lighting pattern that comes from the side, giving the belly dimension. I control the fill light to create more or less drama with my lighting ratio. The primary image *(facing page)* is about a 4:1 lighting ratio, creating deeper shadows.

I had photographed this couple's wedding; the little boy is her child from a previous marriage. They are a loving family, and it was important to me to show the love the three of them already have for the new baby who would soon be making an appearance.

Earning Mom's Trust

Mom was extremely nervous and self-conscious about showing her very pregnant belly and wanted to be sure that her stretch marks would be removed. We started by having her draped all in black, with the bottom of her blouse pulled down. As

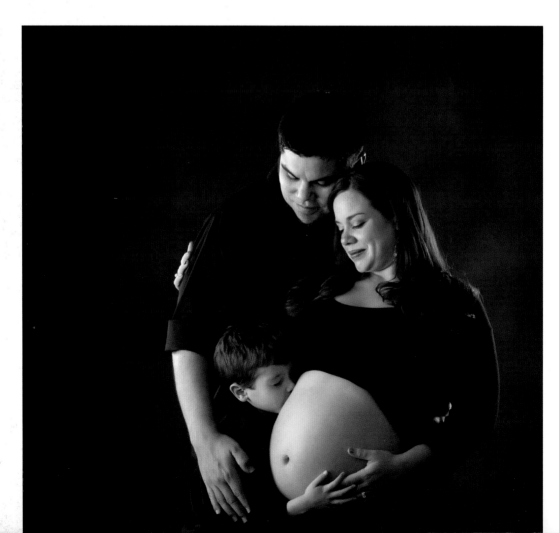

the session progressed, she loosened up and I was able to gain her trust. By earning her trust, I was able to show a little bit more of her belly and capture the images that I think really show off the pregnancy.

Black & White versus Color

I felt that black & white complemented these photographs, allowing for the simplicity and dramatic lighting to be the center of interest, instead of multiple color tones catching the eye. Although the original captures were created in color, these relationship sessions are designed to be printed in black & white on fine art paper.

Exposure, Lighting, and Settings

The primary image was photographed with the 70–200mm lens on my Canon 5D Mark III set at 150mm. My exposure was f/9 at $\frac{1}{125}$ second and ISO 100.

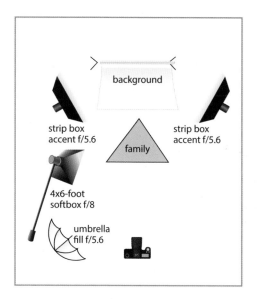

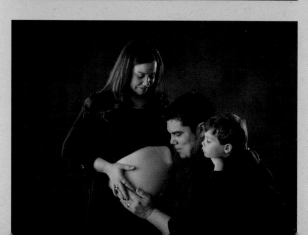

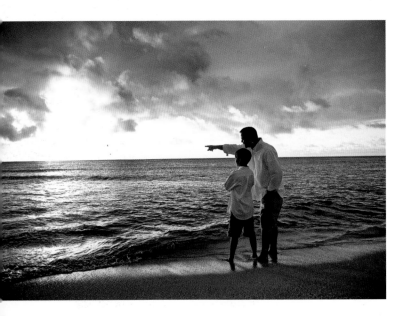

Footsteps in the Sand

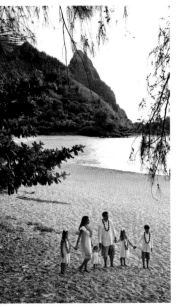

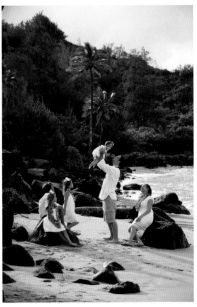

Destination Portraits

This photographic painting was a capture of one of our premiere clients from San Antonio who joined us in Kauai, Hawaii.

After settling into their condo, they followed Trey and me to the beach destinations. We had discussed the locations in advance and I told them about two places that I thought would be great for portraits. Our first stop was where they were sitting on the large lava rocks, which was just off the highway on our way to the beach. The kids were little, so we did not want to test them too much; two locations seemed to be just right for them.

Learn to Work Quickly

I was going to try to photograph all of the different combinations; however, because of their ages, I would have to work quickly so that they did not get bored or tired. The older children would be pretty easy to work with, but I was concerned about the little girl; I wanted to be sure that everyone was happy. Fortunately, the baby had a good nap and she was good to go.

Vacationing Families Are Relaxed

The great thing about photographing families while on vacation is that they are more

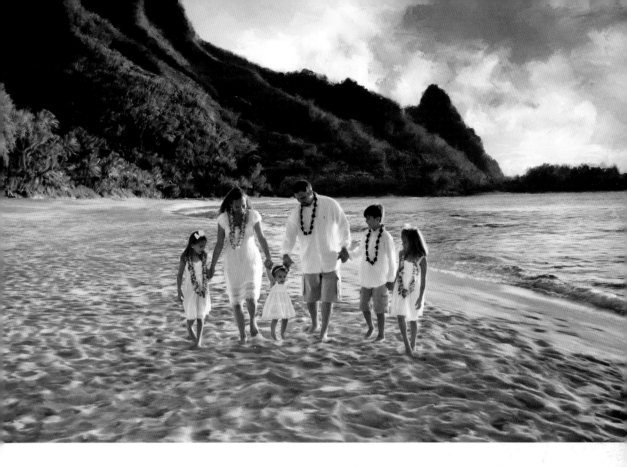

relaxed than if we tried to squeeze a session in after Mom or Dad worked half a day at home. There is usually no stress about being late, because there is no place for them to go except to be with us. They have already decompressed and are in an environment that is beautiful, and the kids are seeing things for the first time.

Be Alert for Unexpected Treasures

As I was photographing Mom and her daughters together, I saw Dad over my shoulder pointing out a sea turtle to his son (*above*); I just swung around and captured the image. This was one of my favorite photographs because of how it looked and because it was real and not posed.

Exposure, Lighting, and Setting Information

We created the primary portrait (*above*) a little before sunset with the sun still strong in the sky. I used a 70–200mm lens on my Canon 5D Mark III set at 70mm. My exposure was f/5 at $\frac{1}{125}$ second and ISO 100.

early morning session

off-camera flash

family

sun

open sky

open sky

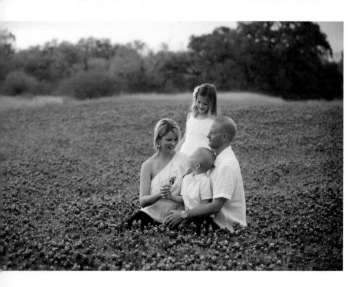

Unique Designs

I loved this image *(facing page)* so much that I have it on display in my studio as a 90-inch skinny portrait, 30x90 inches, which cuts off a good portion of the sky and a portion of the bluebonnets on the bottom of the photo. One of the reasons I have it on display is to show my clients that it is okay to get something that is uniquely shaped. For those who have the right space, something this size and shape will be dynamic. Many people cannot think outside the box, and by seeing something like this, they get the opportunity to visualize portraits in non-standard sizes and formats. I am a believer that you will sell what you show and by my having odd-sized images on my display walls, my clients are not afraid to purchase portraits that are not a 16x20-, 20x24-, or 24x30-inch standard-size image.

Create a Market for Your Top Product

I display a lot of photographic paintings on my studio walls. It is my Signature series and my highest end product; this is what I would like to be recognized for by the people in my area. I have both paintings and traditional images in the sales room and the paintings get a lot of attention. The

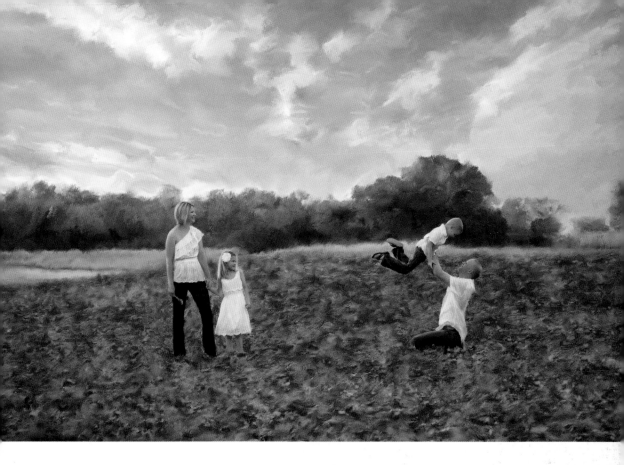

paintings are a larger investment, and not everybody has it in their budget. However, having a high end product such as this will help to sell my other beautiful products, such as canvases, more readily.

The brush strokes look very real on these images, and my clients often walk up to them and remark that they are a painting. I explain that, yes, it is, but it started as a photograph. One of the advantages to the painting is that the fields of bluebonnets are not always this full, or they are trampled after we have walked through the field. However, with a painting, I can fill in and expand the field of bluebonnets to fit my need.

Exposure, Lighting, and Setting Information

The primary image was photographed with the 18–70mm lens on my Canon 5D Mark III set at 60mm. My exposure was f/4.5 at $\frac{1}{125}$ second and ISO 640.

Proper Use of an Old Shed with Character

I love using old buildings as a backdrop, but you have to be careful that parts of the building do not visually dissect or intersect any heads or other body parts. I made sure that the barn was off to the side and

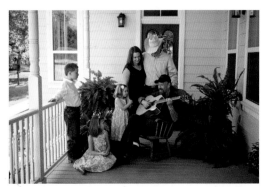

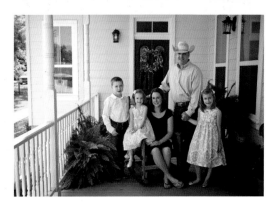

not in conflict with my subjects. This shed had a lot of character with the red painted upper portion sitting on top of the rusted bottom half and the shade askew in the shed's window.

Include Everybody in the Secondary Images

This is another of our premiere clients; I had photographed their wedding and their children from the time they were babies as they were growing up. We were even able to coax Grandpa to pose for a few photos, playing the guitar on their porch, as well as get photos with Grandma. All of the family members live on this farm of several acres, which is on the outskirts of San Antonio.

The little boy showed his disdain for his two sisters as they kissed him on the porch of their house. Since this portrait was made, Mom had another daughter, so he is still

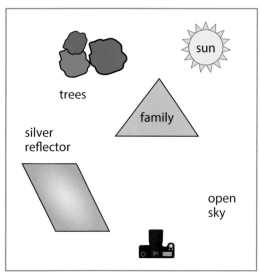

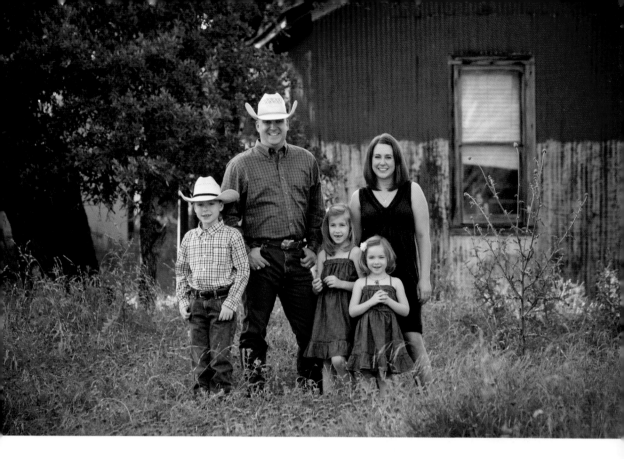

the only boy now with three sisters. He has grown up since this was made, but he does not like being kissed by his sisters anymore now than he did then. I have them kiss him all the time in the photos and he hates it but always obliges.

Late Day Sun, Exposure, and Settings

This series of images was created on their property a little before sunset. For the primary image *(above)*, the sun was starting to go down behind the shed on camera right, so I used a silver reflector on camera left to bounce light back into their eyes and faces. The primary image was photographed with the 70–200mm lens on my Canon 5D Mark III set at 125mm. My exposure was f/5 at $\frac{1}{125}$ second and ISO 400.

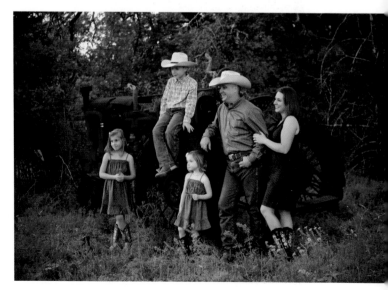

Sometimes Mom Does What She Wants

I had a clothing consultation with the family a few weeks prior to the portrait session, and as always, I talked about keeping the tones simple and neutral, and most importantly, everyone in the same colors, or at least complement colors. However, Mom did not want everyone wearing the same colors, or even the same tones, and she was partial to orange. She had them dress similarly when we had photographed them in the past, and this time she wanted some-

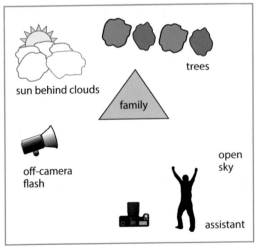

thing different where everyone was wearing bright colors.

Creating a Simple Portrait

This portrait was made in a field next to my studio, which was perfect with the Western-style clothing that Dad was wearing and the style of their home where the photograph would be hung. They were seeking a rustic type of look that was nondescript. They did not want anything with a lot of structure to it, even though we did some images using our cabin as a backdrop. Their main goal was to create a portrait that was simple and without a prop or buildings.

The primary image *(above)* was one of the first photographs that I made; it sometimes takes a little while to figure things out. In the subsequent images, I strategically placed her daughters in front of her; it is not that she was a large woman, but she was larger than the rest of the family and by covering part of her created a slimming effect and made the images more flattering.

Exposure, Lighting, and Settings

The primary image was photographed with the 70–200mm lens on my Canon 5D Mark III set at 110mm. My exposure was f/6.3 at $\frac{1}{125}$ second and ISO 200. I used an off-camera flash on camera left because I needed some extra light to fill in their faces; they were standing in front of a series of trees and the sun was high in the sky behind them on the left, obscured by clouds.

Pets Are People Too

Pets are very much a part of the family, so when this family brought their dog, it was very welcome. A dog with two small children might be a problem, but usually they are collared, on a leash and under control. I encourage families to bring their four-legged family member to be part of the portrait, unless it would be too much stress for them. This was an older dog that was very sweet and easy to work with. The kids were teenagers, and they were great with the dog and gave me wonderful expressions.

Overcoming the Non-Smiler

The hardest person to obtain a smile from was Dad. The family portrait was not his idea or his thing, and he was not too keen on the whole concept. They came to us for one of my Fall Special Portrait Days, and I promised Dad that he only had to spend one hour with me. Most dads comply and cooperate while they are with me. However, I do not know what happens before I get there or after I leave. It is evident by looking at the photos that he was not a smiler, and that is okay, as long as he is there and works with me.

Making Dad Smile

One thing that really helps to get Dad on board is letting Mom and him be close and snuggly. Usu-

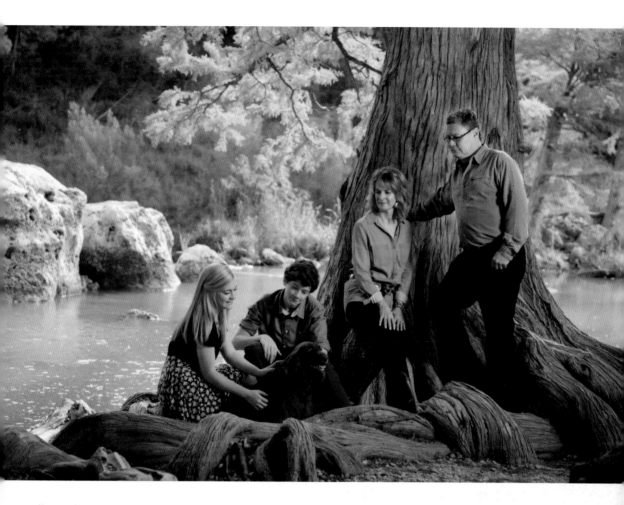

ally Dad wants to snuggle more than Mom, and if I can have Dad put his arm around her,

or put his hand where he wants, like on her backside, that makes him smile. If it makes him happy, I am all for it. I have had a few men say that if they knew that they were going to be able to hug and kiss their wife, they would not have dreaded the session. I encourage them because I want the session to be a fun time for everybody, including Dad.

Exposure, Lighting, and Settings

The primary image was photographed with the 70–200mm lens on my Canon 5D Mark III set at 70mm. My exposure was f/4 at $\frac{1}{160}$ second and ISO 320.

Index

A

albums , 7, 43, 45, 51, 55,
61, 67, 69, 75, 82, 85,
95, 102, 105

architecture and buildings,
22, 24–25, 38–39, 62–63,
82, 84, 86–87

assistants, 7, 12, 16–17, 23,
33, 36, 48, 54, 56, 63,
69, 73, 81, 84, 87, 89,
99, 101

autumn, 14–15

B

backgrounds, 10, 16, 22,
32, 49, 60, 67, 70, 87,
94–95, 112–13

birds, *see seagulls*

black & white, 48, 70,
94–95, 102–03, 114–115

breakdowns, 8, 19, 45, 102

C

children, 8, 12, 15, 17, 18,
33, 36, 48–49, 51, 64–65,
66–67, 98–99, 120–21

children, babies, 29, 71,
48–49, 71, 81, 90, 120

children, active, 62–63,
10, 106

children, keeping atten-
tive, 9, 25, 81, 116

children, small, 6–7, 29

children, special needs,
30–31

children, teenagers,
10–11, 46, 47,

clients,

clients, new, 6–7, 30, 32,
42, 45, 51, 54, 61, 96–97,

clients, educating, 15, 34,
64, 82, 118

clients, understanding and
working with, 8, 15, 34,
38–39, 42, 68, 74–75, 81,
82, 92, 113

clients, repeat/maintain-
ing, 25, 34, 43, 46, 52,
68, 72, 74–75, 76–77, 82,
85, 90, 98, 106, 116, 120

clothing, 14–15, 17, 20, 32,
41, 42, 47, 48, 59, 64,
74, 77, 92, 97, 100, 105,
113, 122–23

clouds, 10–11, 13, 17, 20,
23, 55, 61, 78, 81, 83,
89, 123

color, 14, 18, 34, 41, 48,
59, 68, 77, 78, 80, 86,
91, 95, 96–97, 100,
108–09, 115, 122

color scheme, 8, 22,41

communication, 40, 89, 99

composition, 22, 32–33, 39,

53, 55, 75, 82

consultations, 28, 38–39,
52, 65, 108–09, 122

D

depth, 87, 97

directing subject's atten-
tions, 9, 22, 25

drama, 114–15

E

expression, 7, 12–13, 16,
26, 29, 33, 35, 36, 42–43,
48, 56, 62, 64–65, 67, 69,
74, 89, 93, 99. 100–01,
106, 124

G

grandparents, 8–9, 16–17,
18–19, 24, 44, 68, 94–95

groups, 8, 12, 18, 45, 70,
88, 99, 100–01, 108–09

H

humor, 15, 35, 29, 54–65

L

levels, placement, 8, 64–65,
64–65, 97

lighting,
indirect lighting, 56,
86–87

(*lighting cont.*)

off–camera flash, 13, 17–17, 22–23, 24–25, 32–33, 38–39, 46–47, 50–51

studio lighting, 49

location, 38

location, beach, 10–11, 16–17, 78–79, 92–93, 98–99, 106–07, 116–17

location, gardens, 8–9, 42–43, 18–19, 64–65, 110–11

location, homes, 30–31, 40–41, 50–51, 54–55, 58–59, 70–71

location, missions, 38–39, 40–41, 60–61, 62–63, 86–87

location, parks,104,05,

location permits and per-mission, 77

location, seasonal, 28, 44–45, 118–19

location, travel destina-tions, 24–25, 34, 46–47, 98–99, 106–07, 116–17

location, urban, 22–23, 24–25, 46–47

M

marketing and products, 119, 124

memories, 30, 32–33, 52, 55

motifs, 82–83, 90–91, 116–17

P

pets, 58, 74, 76, 124

planning, 14, 18, 22, 38

portraits

portraits, destination, 24–25, 34, 98–99, 106–07, 116–17

portraits, generational, 44–45, 68–69

portraits, maternity, 114–15,

painted portraits, 14–15, 51, 76, 78–79, 116, 118–19

relational portraits, 114–15, 100–01,

seasonal portraits, 61, 105–06

studio portraits, 48–49, 70–71, 113

poses,

fun–catured pose, 67, 68

interactive pose, 26, 50–51, 66, 76, 107

look-at-the-camera pose, 60–61

Mom and Dad in back-ground pose, 66–67

smiling-making pose, 7

traditional pose, 70–71

walking away pose, 20–21, 98–99

posing, 7, 15, 17, 20–21, 22, 36–37, 45, 50–51, 53, 56, 82, 84, 101, 102, 104–05, 110–11, 120–21

postproduction, 31, 41

preparation, 40–41, 70, 83

props, 42, 44–45, 84

proportions, minimizing, 34–35,

R

referrals, 6, 92

reflectors, 7, 9, 37, 39, 45, 53, 57, 64, 69, 71, 76, 79, 83, 84, 89, 104, 106, 109, 111, 112–13, 121

S

sales, 7, 53, 101, 118

seagulls, 16, 20–21

shade, 9, 19, 39, 56, 61, 88, 104, 120

smiles, 7, 12, 25, 26, 27, 29, 33, 36, 42, 56, 61, 66, 72, 74, 97, 99, 101, 102, 124–25

story, 12, 26, 31, 50–51

studio, outdoor, 68, 84–85, 113, 123

T

time of day, 6, 39

V

variety, 12, 51, 94–95,

W

wall collections, 51, 95, 102–03, 107

wind, 10–11, 16–17, 20–21, 30, 107